Jerry Bauer

About the Author

BILL BRYSON's bestselling books include *One Summer*, *A Short History of Nearly Everything*, *At Home*, *A Walk in the Woods*, *Neither Here nor There*, *Made in America*, and *The Lost Continent*. He lives in England with his wife.

Eminent Lives, a series of brief biographies by distinguished authors on canonical figures, joins a long tradition in this lively form, from Plutarch's *Lives* to Vasari's *Lives of the Painters*, Dr. Johnson's *Lives of the Poets* to Lytton Strachey's *Eminent Victorians*. Pairing great subjects with writers known for their strong sensibilities and sharp, lively points of view, the Eminent Lives are ideal introductions designed to appeal to the general reader, the student, and the scholar. "To preserve a becoming brevity which excludes everything that is redundant and nothing that is significant," wrote Strachey: "That, surely, is the first duty of the biographer."

BOOKS IN THE EMINENT LIVES SERIES

Michael Korda on Ulysses S. Grant

Robert Gottlieb on George Balanchine

Christopher Hitchens on Thomas Jefferson

Paul Johnson on George Washington

Francine Prose on Caravaggio

Edmund Morris on Beethoven

Matt Ridley on Francis Crick

Karen Armstrong on Muhammad

Peter Kramer on Freud

Joseph Epstein on Alexis de Tocqueville

Ross King on Machiavelli

Bill Bryson on William Shakespeare

GENERAL EDITOR: JAMES ATLAS

ALSO BY BILL BRYSON

The Lost Continent

The Mother Tongue

Neither Here nor There

Made in America

A Walk in the Woods

I'm a Stranger Here Myself

In a Sunburned Country

Bryson's Dictionary of Troublesome Words

Bill Bryson's African Diary

A Short History of Nearly Everything

A Short History of Nearly Everything: Special Illustrated Edition

The Life and Times of the Thunderbolt Kid

Bryson's Dictionary for Writers and Editors

At Home: A Short History of Private Life

One Summer: America, 1927

The Road to Little Dribbling

SHAKESPEARE

The World as Stage

Bill Bryson

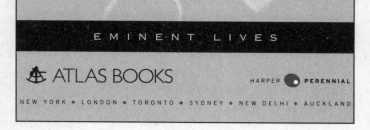

EMINENT LIVES

⚓ ATLAS BOOKS HARPER ● PERENNIAL

NEW YORK • LONDON • TORONTO • SYDNEY • NEW DELHI • AUCKLAND

HARPER ● PERENNIAL

FIRST HARPER PERENNIAL EDITION PUBLISHED 2008.
REISSUED WITH A NEW INTRODUCTION 2016.

Designed by William Ruoto

The Library of Congress has catalogued the hardcover edition
as follows:

Bryson, Bill.
Shakespeare : the world as stage / Bill Bryson. — 1st ed.
p. cm. — (Eminent lives)
ISBN 978-0-06-074022-1
Includes bibliographical references.
1. Shakespeare, William, 1564–1616. 2.
Dramatists, English—Early modern, 1500–1700—Biography. I. Title.
PR2895.B79 2007
822.3'3—dc22
[B] 2007021647

ISBN 978-0-06-256462-7 (pbk.)

16 17 18 19 20 ID/RRD 10 9 8 7 6 5 4 3 2

Acknowledgments

IN ADDITION TO THE kindly and patient interviewees cited in the text, I am grateful to the following for their generous assistance: Mario Aleppo, Anna Bulow, Charles Elliott, Will Francis, Emma French, Peter Furtado, Carol Heaton, Gerald Howard, Jonathan Levi, Jacqui Shepard, Paulette Thompson, and Ed Weisman. I am especially indebted to Professor Stanley Wells and Dr. Paul Edmondson of the Shakespeare Birthplace Trust in Stratford-upon-Avon for generously reviewing the manuscript and suggesting many corrections and prudent qualifications, though of course any errors that remain are mine alone. Special thanks also to James Atlas for his enthusiastic encouragement throughout, and to the astute and kindly copy editors Robert Lacey and Sue Llewellyn. As always, and above all, my greatest debt and most heartfelt thanks go to my dear wife, Cynthia.

To Finley and Molly and in memory of Maisie

Introduction

A FEW YEARS AGO, a kindly New York publisher named James Atlas approached me out of the blue and asked me if I would like to write a biography for a series of books he was launching, to be called Eminent Lives.

Each book in the series was to be about forty thousand words, considerably less than half the length of a conventional biography. The idea was that each book would be long enough to have some substance while yet remaining concise.

James sent me a list of the subjects that had already been assigned. I was disappointed to find that nearly all the figures that jumped to my mind as candidates had already been taken. It was only when I went through the list a second time that I realized that no one had selected William Shakespeare, and impetuously I offered to take him on. To my surprise, and slight subsequent panic, James readily assented.

I hardly need point out that I am not a Shakespearean authority, but luckily Britain is full of people who are, and prudently I turned to them. The book that follows has almost nothing to do with what I think of William Shakespeare (though I admire him very much, of course), but is instead about what I learned of William Shakespeare from people who have spent lifetimes studying and thinking about him. I remain

immensely grateful to them all, in particular to the great and scholarly Stanley Wells, now retired as chairman of the Shakespeare Birthplace Trust.

What is perhaps most extraordinary about William Shakespeare, bearing in mind that he has been dead for four hundred years, is how lively his world remains. Hardly a month goes by that there isn't some fairly momentous claim or discovery relating to his life or work—never more or so perhaps than in 2015 when a South African academic named Francis Thackeray suggested that Shakespeare may have filled the bowl of his little clay pipe with marijuana and possibly even cocaine. The assertion is based on an analysis of pipe remains found in the garden of New Place, Shakespeare's last home in Stratford-upon-Avon. Never mind that nobody knows whether Shakespeare ever actually smoked a pipe or whether the pipe fragments belonged to him or his gardener or someone who owned the property later. Still, if it turns out that *anybody* in Elizabethan England was smoking cannabis and cocaine, that would be arresting news indeed, and it has to be said that no one would have examined the pipe fragments so fastidiously had there not been a Shakespeare connection.

Three other rather more notable events have bounced into the world of Shakespearean scholarship since this volume was first published and should perhaps be mentioned here. The most exciting—not to say incendiary—was the announcement in 2009 by the Shakespeare Birthplace Trust that it had acquired a new and definitive portrait of William Shakespeare. Called the Cobbe portrait, it is the work of an unknown

artist, and shows a youthful, rather dashing man of healthy complexion, dapper attire, and a keen air of intelligence and sensitivity, all of which stands in sharp contrast to the other existing likenesses said to be of Shakespeare. The painting had previously hung in the Cobbe family ancestral home near Dublin and was long thought to be a portrait of Sir Walter Raleigh.

"I was skeptical indeed to begin with," Stanley Wells told me at the time of the unveiling. "There are a lot of paintings that have been claimed to be of William Shakespeare on pretty dubious grounds. But the more I considered the evidence for this one, the more I grew persuaded. I would say I am ninety percent convinced now it is genuine."

It is a terribly exciting thought. Unfortunately, it has also encountered a good deal of criticism. Sir Roy Strong, the art historian, dismissed claims for the portrait's authenticity as "codswallop." Katherine Duncan-Jones of Oxford University thought the man in the portrait "too grand and courtier-like to be Shakespeare" and, in a long, critical article for the *Times Literary Supplement*, characterized the evidence as "not hugely compelling." She suggested it was a portrait of a Sir Thomas Overbury.

At about the same time that the Cobbe portrait came to light, archaeologists from the Museum of London caused much scholarly excitement by announcing the discovery of the foundations of London's first purpose-built theater on the site of a disused warehouse in Shoreditch in east London. Built in 1576 and so indubitably original that it was called simply

the Theatre, it is the oldest theater positively associated with Shakespeare and probably was where *Romeo and Juliet* was first performed.

Soon afterward, archaeologists also found the foundations of a nearby theater, with similar Shakespeare connections, called the Curtain. Only modest fragments of both theaters survive, but so little is known about the physical aspects of Elizabethan theaters that even the discovery of some small ruins of brick and stone is a matter of excitement and value.

Also causing a pleasant stir was the rediscovery and return to Durham University of a missing First Folio of Shakespeare's plays taken from the university library by a light-fingered opportunist in 1998. It had been gone for so long that most people had assumed it to be lost forever. Happily, the volume was sent for a valuation to the Folger Shakespeare Library in Washington, DC, where it was recognized as the missing Durham volume. The Folger alerted the FBI and a man named Raymond Scott was arrested, tried, and eventually sentenced to eight years in prison for the theft.

The folio, mercifully undamaged, is now back in the university library on Palace Green in Durham, where it had resided peacefully since 1664. The question of how many First Folios there are in the world is an interesting and surprisingly challenging one, and is discussed at some length in the pages that follow. Suffice it to say for the moment that the rediscovery of one missing volume is cause for rejoicing. I am faithfully assured that it will not be stolen again.

SHAKESPEARE

Chapter One

In Search of William Shakespeare

BEFORE HE CAME INTO a lot of money in 1839, Richard Plantagenet Temple Nugent Brydges Chandos Grenville, second Duke of Buckingham and Chandos, led a largely uneventful life.

He sired an illegitimate child in Italy, spoke occasionally in the Houses of Parliament against the repeal of the Corn Laws, and developed an early interest in plumbing (his house at Stowe, in Buckinghamshire, had nine of the first flush toilets in England), but otherwise was distinguished by nothing more than his glorious prospects and many names. But after inheriting his titles and one of England's great estates, he astonished his associates, and no doubt himself, by managing to lose every penny of his inheritance in just nine years through a series of spectacularly unsound investments.

Bankrupt and humiliated, in the summer of 1848 he fled to France, leaving Stowe and its contents to his creditors. The

auction that followed became one of the great social events of the age. Such was the richness of Stowe's furnishings that it took a team of auctioneers from the London firm of Christie and Manson forty days to get through it all.

Among the lesser-noted disposals was a dark oval portrait, twenty-two inches high by eighteen wide, purchased by the Earl of Ellesmere for 355 guineas and known ever since as the Chandos portrait. The painting had been much retouched and was so blackened with time that a great deal of detail was (and still is) lost. It shows a balding but not unhandsome man of about forty who sports a trim beard. In his left ear he wears a gold earring. His expression is confident, serenely rakish. This is not a man, you sense, to whom you would lightly entrust a wife or grown daughter.

Although nothing is known about the origin of the painting or where it was for much of the time before it came into the Chandos family in 1747, it has been said for a long time to be of William Shakespeare. Certainly it *looks* like William Shakespeare—but then really it ought to, since it is one of the three likenesses of Shakespeare from which all other such likenesses are taken.

In 1856, shortly before his death, Lord Ellesmere gave the painting to the new National Portrait Gallery in London as its founding work. As the gallery's first acquisition, it has a certain sentimental prestige, but almost at once its authenticity was doubted. Many critics at the time thought the subject was too dark-skinned and foreign looking—too Italian or Jewish—to be an English poet, much less a very great one. Some, to quote

the late Samuel Schoenbaum, were disturbed by his "wanton" air and "lubricious" lips. (One suggested, perhaps a touch hopefully, that he was portrayed in stage makeup, probably in the role of Shylock.)

"Well, the painting is from the right period—we can certainly say that much," Dr. Tarnya Cooper, curator of sixteenth-century portraits at the gallery, told me one day when I set off to find out what we could know and reasonably assume about the most venerated figure of the English language. "The collar is of a type that was popular between about 1590 and 1610, just when Shakespeare was having his greatest success and thus most likely to sit for a portrait. We can also tell that the subject was a bit bohemian, which would seem consistent with a theatrical career, and that he was at least fairly well to do, as Shakespeare would have been in this period."

I asked how she could tell these things.

"Well, the earring tells us he was bohemian," she explained. "An earring on a man meant the same then as it does now—that the wearer was a little more fashionably racy than the average person. Drake and Raleigh were both painted with earrings. It was their way of announcing that they were of an adventurous disposition. Men who could afford to wore a lot of jewelry back then, mostly sewn into their clothes. So the subject here is either fairly discreet, or not hugely wealthy. I would guess probably the latter. On the other hand, we can tell that he was prosperous—or wished us to think he was prosperous—because he is dressed all in black."

She smiled at my look of puzzlement. "It takes a lot of dye

to make a fabric really black. Much cheaper to produce clothes that were fawn or beige or some other lighter color. So black clothes in the sixteenth century were nearly always a sign of prosperity."

She considered the painting appraisingly. "It's not a *bad* painting, but not a terribly good one either," she went on. "It was painted by someone who knew how to prime a canvas, so he'd had some training, but it is quite workaday and not well lighted. The main thing is that if it is Shakespeare, it is the only portrait known that might have been done from life, so this would be what William Shakespeare really looked like—if it is William Shakespeare."

And what are the chances that it is?

"Without documentation of its provenance we'll never know, and it's unlikely now, after such a passage of time, that such documentation will ever turn up."

And if not Shakespeare, who is it?

She smiled. "We've no idea."

If the Chandos portrait is not genuine, then we are left with two other possible likenesses to help us decide what William Shakespeare looked like. The first is the copperplate engraving that appeared as the frontispiece of the collected works of Shakespeare in 1623—the famous First Folio.

The Droeshout engraving, as it is known (after its artist, Martin Droeshout), is an arrestingly—we might almost say magnificently—mediocre piece of work. Nearly everything about it is flawed. One eye is bigger than the other. The mouth

is curiously mispositioned. The hair is longer on one side of the subject's head than the other, and the head itself is out of proportion to the body and seems to float off the shoulders, like a balloon. Worst of all, the subject looks diffident, apologetic, almost frightened—nothing like the gallant and confident figure that speaks to us from the plays.

Droeshout (or Drossaert or Drussoit, as he was sometimes known in his own time) is nearly always described as being from a family of Flemish artists, though in fact the Droeshouts had been in England for sixty years and three generations by the time Martin came along. Peter W. M. Blayney, the leading authority on the First Folio, has suggested that Droeshout, who was in his early twenties and not very experienced when he executed the work, may have won the commission not because he was an accomplished artist but because he owned the right piece of equipment: a rolling press of the type needed for copperplate engravings. Few artists had such a device in the 1620s.

Despite its many shortcomings, the engraving comes with a poetic endorsement from Ben Jonson, who says of it in his memorial to Shakespeare in the First Folio:

> *O, could he but have drawne his wit*
> *As well in brasse, as he hath hit*
> *His face, the Print would then surpasse*
> *All that was ever writ in brasse.*

It has been suggested, with some plausibility, that Jonson may not actually have seen the Droeshout engraving before

penning his generous lines. What is certain is that the Droeshout portrait was not done from life: Shakespeare had been dead for seven years by the time of the First Folio.

That leaves us with just one other possible likeness: the painted, life-size statue that forms the centerpiece of a wall monument to Shakespeare at Holy Trinity Church in Stratford-upon-Avon, where he is buried. Like the Droeshout, it is an indifferent piece of work artistically, but it does have the merit of having been seen and presumably passed as satisfactory by people who knew Shakespeare. It was executed by a mason named Gheerart Janssen, and installed in the chancel of the church by 1623—the same year as Droeshout's portrait. Janssen lived and worked near the Globe Theatre in Southwark in London and thus may well have seen Shakespeare in life—though one rather hopes not, as the Shakespeare he portrays is a puffy-faced, self-satisfied figure, with (as Mark Twain memorably put it) the "deep, deep, subtle, subtle expression of a bladder."

We don't know exactly what the effigy looked like originally because in 1749 the colors of its paintwork were "refreshed" by some anonymous but well-meaning soul. Twenty-four years later the Shakespeare scholar Edmond Malone, visiting the church, was horrified to find the bust painted and ordered the churchwardens to have it whitewashed, returning it to what he wrongly assumed was its original state. By the time it was repainted again years later, no one had any idea of what colors to apply. The matter is of consequence because the paint gives the portrait not just color but definition, as much of the detail is not

carved on but painted. Under whitewash it must have looked rather like those featureless mannequins once commonly used to display hats in shopwindows.

So we are in the curious position with William Shakespeare of having three likenesses from which all others are derived: two that aren't very good by artists working years after his death and one that is rather more compelling as a portrait but that may well be of someone else altogether. The paradoxical consequence is that we all recognize a likeness of Shakespeare the instant we see one, and yet we don't really know what he looked like. It is like this with nearly every aspect of his life and character: He is at once the best known and least known of figures.

More than two hundred years ago, in a sentiment much repeated ever since, the historian George Steevens observed that all we know of William Shakespeare is contained within a few scanty facts: that he was born in Stratford-upon-Avon, produced a family there, went to London, became an actor and writer, returned to Stratford, made a will, and died. That wasn't quite true then and it is even less so now, but it is not all that far from the truth either.

After four hundred years of dedicated hunting, researchers have found about a hundred documents relating to William Shakespeare and his immediate family—baptismal records, title deeds, tax certificates, marriage bonds, writs of attachment, court records (many court records—it was a litigious age), and so on. That's quite a good number as these things go,

but deeds and bonds and other records are inevitably bloodless. They tell us a great deal about the business of a person's life, but almost nothing about the emotions of it.

In consequence there remains an enormous amount that we don't know about William Shakespeare, much of it of a fundamental nature. We don't know, for one thing, exactly how many plays he wrote or in what order he wrote them. We can deduce something of what he read but don't know where he got the books or what he did with them when he had finished with them.

Although he left nearly a million words of text, we have just fourteen words in his own hand—his name signed six times and the words "by me" on his will. Not a single note or letter or page of manuscript survives. (Some authorities believe that a section of the play *Sir Thomas More*, which was never performed, is in Shakespeare's hand, but that is far from certain.) We have no written description of him penned in his own lifetime. The first textual portrait—"he was a handsome, well-shap't man: very good company, and of a very readie and pleasant smooth witt"—was written sixty-four years after his death by a man, John Aubrey, who was born ten years after that death.

Shakespeare seems to have been the mildest of fellows, and yet the earliest written account we have of him is an attack on his character by a fellow artist. He appears to many biographers to have spurned his wife—famously he left her only his second-best bed in his will, and that as an apparent afterthought—and yet no one wrote more highly, more devotedly, more beamingly, of love and the twining of kindred souls.

We are not sure how best to spell his name—but then nei-
ther, it appears, was he, for the name is never spelled the same
way twice in the signatures that survive. (They read as "Willm
Shaksp," "William Shakespe," "Wm Shakspe," "William
Shakspere," "Willm Shakspere," and "William Shakspeare."
Curiously one spelling he didn't use was the one now univer-
sally attached to his name.) Nor can we be entirely confident
how he pronounced his name. Helge Kökeritz, author of the
definitive *Shakespeare's Pronunciation*, thought it possible that
Shakespeare said it with a short *a*, as in "shack." It may have
been spoken one way in Stratford and another in London, or
he may have been as variable with the pronunciation as he was
with the spelling.

We don't know if he ever left England. We don't know who
his principal companions were or how he amused himself. His
sexuality is an irreconcilable mystery. On only a handful of
days in his life can we say with absolute certainty where he
was. We have no record at all of his whereabouts for the eight
critical years when he left his wife and three young children in
Stratford and became, with almost impossible swiftness, a suc-
cessful playwright in London. By the time he is first mentioned
in print as a playwright, in 1592, his life was already more than
half over.

For the rest, he is a kind of literary equivalent of an elec-
tron—forever there and not there.

To understand why we know as little as we do of William
Shakespeare's life, and what hope we have of knowing more,
I went one day to the Public Record Office—now known as

the National Archives—at Kew, in West London. There I met David Thomas, a compact, cheerful, softspoken man with gray hair, the senior archivist. When I arrived, Thomas was hefting a large, ungainly bound mass of documents—an Exchequer memoranda roll from the Hilary (or winter) term of 1570—onto a long table in his office. A thousand pages of sheepskin parchment, loosely bound and with no two sheets quite matching, it was an unwieldy load requiring both arms to carry. "In some ways the records are extremely good," Thomas told me. "Sheepskin is a marvelously durable medium, though it has to be treated with some care. Whereas ink soaks into the fibers on paper, on sheepskin it stays on the surface, rather like chalk on a blackboard, and so can be rubbed away comparatively easily.

"Sixteenth-century paper was of good quality, too," he went on. "It was made of rags and was virtually acid free, so it has lasted very well."

To my untrained eye, however, the ink had faded to an illegible watery faintness, and the script was of a type that was effectively indecipherable. Moreover the writing on the sheets was not organized in any way that aided the searching eye. Paper and parchment were expensive, so no space was wasted. There were no gaps between paragraphs—indeed, no paragraphs. Where one entry ended, another immediately began, without numbers or headings to identify or separate one case from another. It would be hard to imagine less scannable text. To determine whether a particular volume contained a reference to any one person or event, you would have to read essentially every word—and that isn't always easy even for experts

like Thomas because handwriting at the time was extremely variable.

Elizabethans were as free with their handwriting as they were with their spelling. Handbooks of handwriting suggested up to twenty different—often very different—ways of shaping particular letters. Depending on one's taste, for instance, a letter d could look like a figure eight, a diamond with a tail, a circle with a curlicue, or any of fifteen other shapes. A's could look like h's, e's like o's, f's like s's and l's—in fact nearly every letter could look like nearly every other. Complicating matters further is the fact that court cases were recorded in a distinctive lingua franca known as court hand—"a peculiar clerical Latin that no Roman could read," Thomas told me, smiling. "It used English word order but incorporated an arcane vocabulary and idiosyncratic abbreviations. Even clerks struggled with it because when cases got really complicated or tricky, they would often switch to English for convenience."

Although Thomas knew he had the right page and had studied the document many times, it took him a good minute or more to find the line referring to "John Shappere alias Shakespere" of "Stratford upon Haven," accusing him of usury. The document is of considerable importance to Shakespeare scholars for it helps to explain why in 1576, when Will was twelve years old, his father abruptly retired from public life (about which more in due course), but it was only found in 1983 by a researcher named Wendy Goldsmith.

There are more than a hundred miles of records like this in the National Archives—nearly ten million documents al-

together—in London and in an old salt mine in Cheshire, not all of them from the relevant period, to be sure, but enough to keep the most dedicated researcher busy for decades.

The only certain way to find more would be to look through all the documents. In the early 1900s an odd American couple, Charles and Hulda Wallace, decided to do just that. Charles Wallace was an instructor in English at the University of Nebraska who just after the turn of the century, for reasons unknown, developed a sudden and lasting fixation with determining the details of Shakespeare's life. In 1906 he and Hulda made the first of several trips to London to sift through the records. Eventually they settled there permanently. Working for up to eighteen hours a day, mostly at the Public Record Office on Chancery Lane, as it then was, they pored over hundreds of thousands—Wallace claimed five million*—documents of all types: Exchequer memoranda rolls, property deeds, messuages, pipe rolls, plea rolls, conveyancings, and all the other dusty hoardings of legal life in sixteenth- and early seventeenth-century London.

Their conviction was that Shakespeare, as an active citizen, was bound to turn up in the public records from time to time. The theory was sound enough, but when you consider that there were hundreds of thousands of records, without in-

* This was probably stretching it. If the Wallaces averaged five minutes, say, on each document it would have taken them 416,666 hours to get through five million of them. Even working around the clock, that would represent 47.5 years of searching.

dexes or cross-references, each potentially involving any of two hundred thousand citizens; that Shakespeare's name, if it appeared at all, might be spelled in some eighty different ways, or be blotted or abbreviated beyond recognition; and that there was no reason to suppose that he had been involved in London in any of the things—arrest, marriage, legal disputes, and the like—that got one into the public records in the first place, the Wallaces' devotion was truly extraordinary.

So we may imagine a muffled cry of joy when in 1909 they came across a litigation roll from the Court of Requests in London comprising twenty-six assorted documents that together make up what is known as the Belott-Mountjoy (or Mountjoie) Case. All relate to a dispute in 1612 between Christopher Mountjoy, a refugee Huguenot wigmaker, and his son-in-law, Stephen Belott, over a marriage settlement. Essentially Belott felt that his father-in-law had not given him all that he had promised, and so he took the older man to court.

Shakespeare, it appears, was caught up in the affair because he had been a lodger in Mountjoy's house in Cripplegate in 1604 when the dispute arose. By the time he was called upon to give testimony eight years later, he claimed—not unreasonably—to be unable to remember anything of consequence about what had been agreed upon between his landlord and the landlord's son-in-law.

The case provided no fewer than twenty-four new mentions of Shakespeare and one precious additional signature— the sixth and so far last one found. Moreover it is also the best and most natural of his surviving signatures. This was the one

known occasion when Shakespeare had both space on the page for a normal autograph and a healthily steady hand with which to write it. Even so, as was his custom, he writes the name in an abbreviated form: "Wllm Shaksp." It also has a large blot on the end of the surname, probably because of the comparatively low quality of the paper. Though it is only a deposition, it is also the only document in existence containing a transcript of Shakespeare speaking in his own voice.

The Wallaces' find, reported the following year in the pages of the *University of Nebraska Studies* (and forever likely to remain, we may suppose, that journal's greatest scoop), was important for two other reasons. It tells us where Shakespeare was living at an important point in his career: in a house on the corner of Silver and Monkswell streets near Saint Aldermanbury in the City of London. And the date of Shakespeare's deposition, May 11, 1612, provides one of the remarkably few days in his life when we can say with complete certainty where he was.

The Belott-Mountjoy papers were only part of what the Wallaces found in their years of searching. It is from their work that we know the extent of Shakespeare's financial interests in the Globe and Blackfriars theaters, and of his purchase of a gatehouse at Blackfriars in 1613, just three years before his death. They found a lawsuit in which the daughter of John Heminges, one of Shakespeare's closest colleagues, sued her father over some family property in 1615. For Shakespeare scholars these are moments of monumental significance.

Unfortunately, as time passed Charles Wallace began to grow a little strange. He penned extravagant public tributes to

himself in the third person ("Prior to his researches," read one, "it was believed and taught for nearly 50 years that everything was known about Shakespeare that ever would be known. His remarkable discoveries have changed all this . . . and brought lasting honor to American scholarship") and developed paranoid convictions. He became convinced that other researchers were bribing the desk clerks at the Public Record Office to learn which files he had ordered. Eventually he believed that the British government was secretly employing large numbers of students to uncover Shakespeare records before he could get to them, and claimed as much in an American literary magazine, causing dismay and unhappiness on both sides of the Atlantic.

Short of funds and increasingly disowned by the academic community, he and Hulda gave up on Shakespeare and the English, and moved back to the United States. It was the height of the oil boom in Texas, and Wallace developed another unexpected conviction: He decided that he could recognize good oil land just by looking at it. Following a secret instinct, he sank all his remaining funds in a 160-acre farm in Wichita Falls, Texas. It proved to be one of the most productive oil fields ever found anywhere. He died in 1932, immensely rich and not very happy.

With so little to go on in the way of hard facts, students of Shakespeare's life are left with essentially three possibilities: to pick minutely over legal documents as the Wallaces did; to speculate ("every Shakespeare biography is 5 percent fact and

95 percent conjecture," one Shakespeare scholar told me, possibly in jest); or to persuade themselves that they know more than they actually do. Even the most careful biographers sometimes take a supposition—that Shakespeare was Catholic or happily married or fond of the countryside or kindly disposed toward animals—and convert it within a page or two to something like a certainty. The urge to switch from subjunctive to indicative is, to paraphrase Alastair Fowler, always a powerful one.

Others have simply surrendered themselves to their imaginations. One respected and normally levelheaded academic of the 1930s, the University of London's Caroline F. E. Spurgeon, became persuaded that it was possible to determine Shakespeare's appearance from a careful reading of his text, and confidently announced (in *Shakespeare's Imagery and What It Tells Us*) that he was "a compactly well-built man, probably on the slight side, extraordinarily well-coordinated, lithe and nimble of body, quick and accurate of eye, delighting in swift muscular movement. I suggest that he was probably fair-skinned and of a fresh colour, which in youth came and went easily, revealing his feelings and emotions."

Ivor Brown, a popular historian, meanwhile concluded from mentions of abscesses and other eruptions in Shakespeare's plays that Shakespeare sometime after 1600 had undergone "a severe attack of staphylococcic infection" and was thereafter "plagued with recurrent boils."

Other, literal-minded readers of Shakespeare's sonnets have been struck by two references to lameness, specifically in Sonnet 37:

As a decrepit father takes delight
To see his active child do deeds of youth,
So I, made lame by Fortune's dearest spite,
Take all my comfort of thy worth and truth.

And again in Sonnet 89:

Say that thou didst forsake me for some fault,
And I will comment upon that offense.
Speak of my lameness, and I straight will halt.

and concluded that he was crippled.

In fact it cannot be emphasized too strenuously that there is nothing—not a scrap, not a mote—that gives any certain insight into Shakespeare's feelings or beliefs as a private person. We can know only what came out of his work, never what went into it.

David Thomas is not in the least surprised that he is such a murky figure. "The documentation for William Shakespeare is exactly what you would expect of a person of his position from that time," he says. "It seems like a dearth only because we are so intensely interested in him. In fact we know more about Shakespeare than about almost any other dramatist of his age."

Huge gaps exist for nearly all figures from the period. Thomas Dekker was one of the leading playwrights of the day, but we know little of his life other than that he was born in London, wrote prolifically, and was often in debt. Ben Jonson

was more famous still, but many of the most salient details of his life—the year and place of his birth, the identities of his parents, the number of his children—remain unknown or uncertain. Of Inigo Jones, the great architect and theatrical designer, we have not one certain fact of any type for the first thirty years of his life other than that he most assuredly existed somewhere.

Facts are surprisingly delible things, and in four hundred years a lot of them simply fade away. One of the most popular plays of the age was *Arden of Faversham*, but no one now knows who wrote it. When an author's identity *is* known, that knowledge is often marvelously fortuitous. Thomas Kyd wrote the most successful play of its day, *The Spanish Tragedy*, but we know this only because of a passing reference to his authorship in a document written some twenty years after his death (and then lost for nearly two hundred years).

What we do have for Shakespeare are his plays—all of them but one or two—thanks in very large part to the efforts of his colleagues Henry Condell and John Heminges, who put together a more or less complete volume of his work after his death—the justly revered First Folio. It cannot be overemphasized how fortunate we are to have so many of Shakespeare's works, for the usual condition of sixteenth- and early seventeenth-century plays is to be lost. Few manuscripts from any playwrights survive, and even printed plays are far more often missing than not. Of the approximately three thousand plays thought to have been staged in London from about the time of Shakespeare's birth to the closure of the theaters by the

Puritans in a coup of joylessness in 1642, 80 percent are known only by title. Only 230 or so play texts still exist from Shakespeare's time, including the thirty-eight by Shakespeare himself—about 15 percent of the total, a gloriously staggering proportion.

It is because we have so much of Shakespeare's work that we can appreciate how little we know of him as a person. If we had only his comedies, we would think him a frothy soul. If we had just the sonnets, he would be a man of darkest passions. From a selection of his other works, we might think him variously courtly, cerebral, metaphysical, melancholic, Machiavellian, neurotic, lighthearted, loving, and much more. Shakespeare was of course all these things—as a writer. We hardly know what he was as a person.

Faced with a wealth of text but a poverty of context, scholars have focused obsessively on what they *can* know. They have counted every word he wrote, logged every dib and jot. They can tell us (and have done so) that Shakespeare's works contain 138,198 commas, 26,794 colons, and 15,785 question marks; that ears are spoken of 401 times in his plays; that *dunghill* is used 10 times and *dullard* twice; that his characters refer to love 2,259 times but to hate just 183 times; that he used *damned* 105 times and *bloody* 226 times, but *bloody-minded* only twice; that he wrote *hath* 2,069 times but *has* just 409 times; that all together he left us 884,647 words, made up of 31,959 speeches, spread over 118,406 lines.

They can tell us not only what Shakespeare wrote but what

he read. Geoffrey Bullough devoted a lifetime, nearly, to tracking down all possible sources for virtually everything mentioned in Shakespeare, producing eight volumes of devoted exposition revealing not only what Shakespeare knew but precisely how he knew it. Another scholar, Charlton Hinman, managed to identify individual compositors who worked on the typesetting of Shakespeare's plays. By comparing preferences of spelling—whether a given compositor used *go* or *goe*, *chok'd* or *choakte*, *lantern* or *lanthorn*, *set* or *sett* or *sette*, and so on—and comparing these in turn with idiosyncrasies of punctuation, capitalization, line justification, and the like, he and others have identified nine hands at work on the First Folio. It has been suggested, quite seriously, that thanks to Hinman's detective work we know more about who did what in Isaac Jaggard's London workshop than Jaggard did himself.

Shakespeare, it seems, is not so much a historical figure as an academic obsession. A glance through the indexes of the many scholarly journals devoted to him and his age reveals such dogged investigations as "Linguistic and Informational Entropy in Othello," "Ear Disease and Murder in Hamlet," "Poisson Distributions in Shakespeare's Sonnets," "Shakespeare and the Quebec Nation," "Was Hamlet a Man or a Woman?" and others of similarly inventive cast.

The amount of Shakespearean ink, grossly measured, is almost ludicrous. In the British Library catalog, enter "Shakespeare" as author and you get 13,858 options (as opposed to 455 for "Marlowe," for instance), and as subject you get 16,092 more. The Library of Congress in Washington, D.C., contains

about seven thousand works on Shakespeare—twenty years' worth of reading if read at the rate of one a day—and, as this volume slimly attests, the number keeps growing. *Shakespeare Quarterly*, the most exhaustive of bibliographers, logs about four thousand serious new works—books, monographs, other studies—every year.

To answer the obvious question, this book was written not so much because the world needs another book on Shakespeare as because this series does. The idea is a simple one: to see how much of Shakespeare we can know, really know, from the record.

Which is one reason, of course, it's so slender.

Chapter Two

The Early Years, 1564–1585

WILLIAM SHAKESPEARE WAS BORN into a world that was short of people and struggled to keep those it had. In 1564 England had a population of between three million and five million—much less than three hundred years earlier, when plague began to take a continuous, heavy toll. Now the number of living Britons was actually in retreat. The previous decade had seen a fall in population nationally of about 6 percent. In London as many as a quarter of the citizenry may have perished.

But plague was only the beginning of England's deathly woes. The embattled populace also faced constant danger from tuberculosis, measles, rickets, scurvy, two types of smallpox (confluent and hemorrhagic), scrofula, dysentery, and a vast, amorphous array of fluxes and fevers—tertian fever, quartian fever, puerperal fever, ship's fever, quotidian fever, spotted fever—as well as "frenzies," "foul evils," and other peculiar

maladies of vague and numerous type. These were, of course, no respecters of rank. Queen Elizabeth herself was nearly carried off by smallpox in 1562, two years before William Shakespeare was born.

Even comparatively minor conditions—a kidney stone, an infected wound, a difficult childbirth—could quickly turn lethal. Almost as dangerous as the ailments were the treatments meted out. Victims were purged with gusto and bled till they fainted—hardly the sort of handling that would help a weakened constitution. In such an age it was a rare child that knew all four of its grandparents.

Many of the exotic-sounding diseases of Shakespeare's time are known to us by other names (their ship's fever is our typhus, for instance), but some were mysteriously specific to the age. One such was the "English sweat," which had only recently abated after several murderous outbreaks. It was called "the scourge without dread" because it was so startlingly swift: Victims often sickened and died on the same day. Fortunately many survived, and gradually the population acquired a collective immunity that drove the disease to extinction by the 1550s. Leprosy, one of the great dreads of the Middle Ages, had likewise mercifully abated in recent years, never to return with vigor. But no sooner had these perils vanished than another virulent fever, called "the new sickness," swept through the country, killing tens of thousands in a series of outbreaks between 1556 and 1559. Worse, these coincided with calamitous, starving harvests in 1555 and 1556. It was a literally dreadful age.

Plague, however, remained the darkest scourge. Just under three months after William's birth, the burials section of the parish register of Holy Trinity Church in Stratford bears the ominous words *Hic incepit pestis* (Here begins plague), beside the name of a boy named Oliver Gunne. The outbreak of 1564 was a vicious one. At least two hundred people died in Stratford, about ten times the normal rate. Even in nonplague years 16 percent of infants perished in England; in this year nearly two-thirds did. (One neighbor of the Shakespeare's lost four children.) In a sense William Shakespeare's greatest achievement in life wasn't writing *Hamlet* or the sonnets but just surviving his first year.

We don't know quite when he was born. Much ingenuity has been expended on deducing from one or two certainties and some slender probabilities the date on which he came into the world. By tradition it is agreed to be April 23, Saint George's Day. This is the national day of England, and coincidentally also the date on which Shakespeare died fifty-two years later, giving it a certain irresistible symmetry, but the only actual fact we have concerning the period of his birth is that he was baptized on April 26. The convention of the time—a consequence of the high rates of mortality—was to baptize children swiftly, no later than the first Sunday or holy day following birth, unless there was a compelling reason to delay. If Shakespeare was born on April 23—a Sunday in 1564—then the obvious choice for christening would have been two days later on Saint Mark's Day, April 25. However, some people thought

Saint Mark's Day was unlucky and so, it is argued—perhaps just a touch hopefully—that the christening was postponed an additional day, to April 26.

We are lucky to know as much as we do. Shakespeare was born just at the time when records were first kept with some fidelity. Although all parishes in England had been ordered more than a quarter of a century earlier, in 1538, to maintain registers of births, deaths, and weddings, not all complied. (Many suspected that the state's sudden interest in information gathering was a prelude to some unwelcome new tax.) Stratford didn't begin keeping records until as late as 1558—in time to include Will, but not Anne Hathaway, his older-by-eight-years wife.

One consideration makes arguments about birth dates rather academic anyway. Shakespeare was born under the old Julian calendar, not the Gregorian, which wasn't created until 1582, when Shakespeare was already old enough to marry. In consequence, what was April 23 to Shakespeare would to us today be May 3. Because the Gregorian calendar was of foreign design and commemorated a pope (Gregory XIII), it was rejected in Britain until 1751, so for most of Shakespeare's life, and 135 years beyond, dates in Britain and the rest of Europe were considerably at variance—a matter that has bedeviled historians ever since.

The principal background event of the sixteenth century was England's change from a Catholic society to a Protestant one—though the course was hardly smooth. England swung from

Protestantism under Edward VI to Catholicism under Mary Tudor and back to Protestantism again under Elizabeth. With each change of regime, officials who were too obdurate or dilatory to flee faced painful reprisals, as when Thomas Cranmer, archbishop of Canterbury, and colleagues were burned at the stake in Oxford after the Catholic Mary came to the throne in 1553. The event was graphically commemorated in a book by John Foxe formally called *Actes and Monuments of These Latter and Perillous Days, Touching Matters of the Church* but familiarly known then and ever since as *Foxe's Book of Martyrs*—a book that would provide succor to anti-Catholic passions during the time of Shakespeare's life. It was also a great comfort to Elizabeth, as later editions carried an extra chapter on "The Miraculous Preservation of the Lady Elizabeth, now Queen of England," praising her brave guardianship of Protestantism during her half sister's misguided reign (though in fact Elizabeth was anything but bravely Protestant during Mary's reign).

Though it was an age of huge religious turmoil, and although many were martyred, on the whole the transition to a Protestant society proceeded reasonably smoothly, without civil war or wide-scale slaughter. In the forty-five years of Elizabeth's reign, fewer than two hundred Catholics were executed. This compares with eight thousand Protestant Huguenots killed in Paris alone during the Saint Bartholomew's Day massacre in 1572, and the unknown thousands who died elsewhere in France. That slaughter had a deeply traumatizing effect in England—Christopher Marlowe graphically depicted it in *The Massacre at Paris* and put slaughter scenes in two other

plays—and left two generations of Protestant Britons at once jittery for their skins and ferociously patriotic.

Elizabeth was thirty years old and had been queen for just over five years at the time of William Shakespeare's birth, and she would reign for thirty-nine more, though never easily. In Catholic eyes she was an outlaw and a bastard. She would be bitterly attacked by successive popes, who would first excommunicate her and then openly invite her assassination. Moreover for most of her reign a Catholic substitute was conspicuously standing by: her cousin Mary, Queen of Scots. Because of the dangers to Elizabeth's life, every precaution was taken to preserve her. She was not permitted to be alone out of doors and was closely guarded within. She was urged to be wary of any presents of clothing designed to be worn against her "body bare" for fear that they might be deviously contaminated with plague. Even the chair in which she normally sat was suspected at one point of having been dusted with infectious agents. When it was rumored that an Italian poisoner had joined her court, she had all her Italian servants dismissed. Eventually, trusting no one completely, she slept with an old sword beside her bed.

Even while Elizabeth survived, the issue of her succession remained a national preoccupation throughout her reign—and thus through a good part of William Shakespeare's life. As Frank Kermode has noted, a quarter of Shakespeare's plays would be built around questions of royal succession—though speculating about Elizabeth's successor was very much against the law. A Puritan parliamentarian named Peter Wentworth

languished for ten years in the Tower of London simply for having raised the matter in an essay.

Elizabeth was a fairly relaxed Protestant. She favored many customary Catholic rites (there would be no evensong in English churches now without her) and demanded little more than a token attachment to Anglicanism throughout much of her reign. The interest of the Crown was not so much to direct people's religious beliefs as simply to be assured of their fealty. It is telling that Catholic priests when caught illegally preaching were normally charged not with heresy but with treason. Elizabeth was happy enough to stay with Catholic families on her progresses around the country so long as their devotion to her as monarch was not in doubt. So *being* Catholic was not particularly an act of daring in Elizabethan England. Being publicly Catholic, propagandizing for Catholicism, was another matter, as we shall see.

Catholics who did not wish to attend Anglican services could pay a fine. These nonattenders were known as recusants (from a Latin word for "refusing") and there were a great many of them—an estimated fifty thousand in 1580. Fines for recusancy were only 12 pence until 1581, and in any case were only sporadically imposed, but then they were raised abruptly—and, for most people, crushingly—to £20 a month. Remarkably some two hundred citizens had both the wealth and the piety to sustain such penalties, which proved an unexpected source of revenue to the Crown, raising a very useful £45,000 just at the time of the Spanish Armada.

Most of the queen's subjects, however, were what were known as "church Papists" or "cold statute Protestants"—prepared to support Protestantism so long as required, but happy and perhaps even quietly eager to become Catholics again if circumstances altered.

Protestantism had its dangers, too. Puritans (a word coined with scornful intent in the year of Shakespeare's birth) and Separatists of various stripes also suffered persecution—not so much because of their beliefs or styles of worship as because of their habit of being willfully disobedient to authority and dangerously outspoken. When a prominent Puritan named (all too appropriately, it would seem) John Stubbs criticized the queen's mooted marriage to a French Catholic, the Duke of Alençon, his right hand was cut off.* Holding up his bloody stump and doffing his hat to the crowd, Stubbs shouted, "God save the Queen," fell over in a faint, and was carted off to prison for eighteen months.

In fact he got off comparatively lightly, for punishments could be truly severe. Many convicted felons still heard the chilling words: "You shall be led from hence to the place whence you came . . . and your body shall be opened, your heart

* It was an unlikely courtship. The queen was old enough to be his mother—she was nearly forty, he just eighteen—and the duke moreover was short and famously ugly. (His champions suggested hopefully that he could be made to look better if he grew a beard.) It was only the duke's death in 1584 that finally put an end to the possibility of marriage.

and bowels plucked out, and your privy members cut off and thrown into the fire before your eyes." Actually by Elizabeth's time it had become most unusual for felons to be disemboweled while they were still alive enough to know it. But exceptions were made. In 1586 Elizabeth ordered that Anthony Babington, a wealthy young Catholic who had plotted her assassination, should be made an example of. Babington was hauled down from the scaffold while still conscious and made to watch as his abdomen was sliced open and the contents allowed to spill out. It was by this time an act of such horrifying cruelty that it disgusted even the bloodthirsty crowd.

The monarch enjoyed extremely wide powers of punishment, and Elizabeth used them freely, banishing from court or even imprisoning courtiers who displeased her (by, for instance, marrying without her blessing), sometimes for quite long periods. In theory she enjoyed unlimited powers to detain, at her pleasure, any subject who failed to honor the fine and numerous distinctions that separated one level of society from another—and these were fine and numerous indeed. At the top of the social heap was the monarch, of course. Then came nobles, high clerics, and gentlemen, in that order. These were followed by citizens—which then signified wealthier merchants and the like: the bourgeoisie. Then came yeomen—that is, small farmers—and last came artisans and common laborers.

Sumptuary laws, as they were known, laid down precisely, if preposterously, who could wear what. A person with an income of £20 a year was permitted to don a satin doublet but not a satin gown, while someone worth £100 a year could wear all

the satin he wished, but could have velvet only in his doublets, but not in any outerwear, and then only so long as the velvet was not crimson or blue, colors reserved for knights of the Garter and *their* superiors. Silk netherstockings, meanwhile, were restricted to knights and their eldest sons, and to certain—but not all—envoys and royal attendants. Restrictions existed, too, on the amount of fabric one could use for a particular article of apparel and whether it might be worn pleated or straight and so on through lists of variables almost beyond counting.

The laws were enacted partly for the good of the national accounts, for the restrictions nearly always were directed at imported fabrics. For much the same reasons, there was for a time a Statute of Caps, aimed at helping domestic cap makers through a spell of depression, which required people to wear caps instead of hats. For obscure reasons Puritans resented the law and were often fined for flouting it. Most of the other sumptuary laws weren't actually much enforced, it would seem. The records show almost no prosecutions. Nonetheless they remained on the books until 1604.

Food was similarly regulated, with restrictions placed on how many courses one might eat, depending on status. A cardinal was permitted nine dishes at a meal while those earning less than £40 a year (which is to say most people) were allowed only two courses, plus soup. Happily, since Henry VIII's break with Rome, eating meat on Friday was no longer a hanging offense, though anyone caught eating meat during Lent could still be sent to prison for three months. Church authorities were permitted to sell exemptions to the Lenten rule and made a lot

of money doing so. It's a surprise that there was much demand, for in fact most varieties of light meat, including veal, chicken, and all other poultry, were helpfully categorized as fish.

Nearly every aspect of life was subject to some measure of legal restraint. At a local level, you could be fined for letting your ducks wander in the road, for misappropriating town gravel, for having a guest in your house without a permit from the local bailiff. Our very first encounter with the name Shakespeare is in relation to one such general transgression in 1552, twelve years before William was born, when his father, John, was fined 1 shilling for keeping a dung heap in Henley Street in Stratford. This was a matter not just of civic fussiness but of real concern because of the town's repeated plague outbreaks. A fine of a shilling was a painful penalty—probably equivalent to two days' earnings for Shakespeare.

Not much is known about John Shakespeare's early years. He was born about 1530 and grew up on a farm at nearby Snitterfield, but came to Stratford as a young man (sparing posterity having to think of his son as the Bard of Snitterfield) and became a glover and whittawer—someone who works white or soft leather. It was an eminently respectable trade.

Stratford was a reasonably consequential town. With a population of roughly two thousand at a time when only three cities in Britain had ten thousand inhabitants or more, it stood about eighty-five miles northwest of London—a four-day walk or two-day horseback ride—on one of the main woolpack routes between the capital and Wales. (Travel for nearly everyone was on foot or by horseback, or not at all. Coaches as a

means of public transport were invented in the year of Shakespeare's birth but weren't generally used by the masses until the following century.)

Shakespeare's father is often said (particularly by those who wish to portray William Shakespeare as too deprived of stimulus and education to have written the plays attributed to him) to have been illiterate. Illiteracy was the usual condition in sixteenth-century England, to be sure. According to one estimate at least 70 percent of men and 90 percent of women of the period couldn't even sign their names. But as one moved up the social scale, literacy rates rose appreciably. Among skilled craftsmen—a category that included John Shakespeare—some 60 percent could read, a clearly respectable proportion.

The conclusion of illiteracy with regard to Shakespeare's father is based on the knowledge that he signed his surviving papers with a mark. But lots of Elizabethans, particularly those who liked to think themselves busy men, did likewise even when they could read, rather as busy executives might today scribble their initials in the margins of memos. As Samuel Schoenbaum points out, Adrian Quiney, a Stratford contemporary of the Shakespeares, signed all his known Stratford documents with a cross and would certainly be considered illiterate except that we also happen to have an eloquent letter in his own hand written to William Shakespeare in 1598. It is worth bearing in mind that John Shakespeare rose through a series of positions of authority in which an inability to read would have been a tiresome, if not insuperable, handicap. Anyway, as should be

obvious, his ability to write or not could have had absolutely no bearing on the capabilities of his children.

Literate or not, John was a popular and respected fellow. In 1556 he took up the first of many municipal positions when he was elected borough ale taster. The job required him to make sure that measures and prices were correctly observed throughout the town—not only by innkeepers but also by butchers and bakers. Two years later he became a constable—a position that then, as now, argued for some physical strength and courage—and the next year became an "affeeror" (or "affurer"), someone who assessed fines for matters not handled by existing statutes. Then he became successively burgess, chamberlain, and alderman, which last entitled him to be addressed as "Master" rather than simply as "Goodman." Finally, in 1568, he was placed in the highest elective office in town, high bailiff—mayor in all but name. So William Shakespeare was born into a household of quite a lot of importance locally.

One of John's duties as high bailiff was to approve payment from town funds for performances by visiting troupes of actors. Stratford in the 1570s became a regular stop for touring players, and it is reasonable to suppose that an impressionable young Will saw many plays as he grew up and possibly received some encouragement or made some contact that smoothed his entrance into the London theater later. He would at the very least have seen actors with whom he who would eventually become closely associated.

For four hundred years this was about all that was known of John Shakespeare, but in the 1980s some discoveries at the

Public Record Office showed that there was another, rather more dubious side to his character.

"It appears that he hung out with some fairly shady fellows," says David Thomas. Four times in the 1570s, John was prosecuted (or threatened with prosecution—the records are sometimes a touch unclear) for trading in wool and for money-lending, both highly illegal activities. Usury in particular was considered a "vice most odious and detestable," in the stark phrasing of the law, and fines could be severe, but John seems to have engaged in it at a seriously committed level. In 1570 he was accused of making loans worth £220 (including interest) to a Walter Mussum. This was a very considerable sum—well over £100,000 in today's money—and Mussum appears not to have been a good risk; at his death his entire estate was worth only £114, much less than John Shakespeare had lent him.

The risk attached to such an undertaking was really quite breathtaking. Anyone found guilty of it would forfeit all the money lent, plus interest, and face a stiff fine and the possibility of imprisonment. The law applied—a little unfairly, it must be said—to any extension of credit. If someone took delivery of, say, wool from you with the understanding that he would repay you later, with a little interest for your trouble, that was considered usury, too. It was this form of usury of which John Shakespeare was probably guilty, for he also traded (or so it would seem) in large quantities of wool. In 1571, for instance, he was accused of acquiring 300 tods—8,400 pounds—of wool. That is a lot of wool and a lot of risk.

We cannot be certain how guilty he was. Informers, as

David Thomas points out, sometimes brought actions as a kind of nuisance ploy, hoping that the accused, even if innocent, would agree to an out-of-court settlement rather than face a costly and protracted trial in London, and one of John Shakespeare's accusers did have a record of bringing such malicious suits.

In any case something severely unfavorable seems to have happened in John's business life for in 1576, when William was twelve, he abruptly withdrew from public affairs and stopped attending meetings. He was listed at one point among nine Stratford residents who were thought to have missed church services "for fear of processe for debtte." His colleagues repeatedly reduced or excused levies that he was due to pay. They also kept his name on the membership for another ten years in the evident hope that he would make a recovery. He never did.

Shakespeare's mother, Mary Arden, provides us with a history that is rather more straightforward, if not tremendously vivid or enlightening. She came from a minor branch of a prominent family. Her father farmed, and the family was comfortable, but probably no more than that. She was the mother of eight children: four daughters, of whom only one lived to adulthood, and four sons, all of whom reached their majority but only one of whom, Will, married. Not a great deal is known about any of them apart from Will. Joan, born in 1558, married a local hatter named Hart and lived to be seventy-seven. Gilbert, born in 1566, became a successful haberdasher. Richard was born in 1574 and lived to be not quite forty, and that is all we know

of him. Edmund, the youngest, became an actor in London—
how successfully and with which company are unknown—and
died there at the age of twenty-seven. He is buried in South-
wark Cathedral, the only one of the eight siblings not to rest at
Holy Trinity in Stratford. Seven of the eight Shakespeare chil-
dren appear to have been named after close relations or family
friends. The exception was William, the inspiration for whose
name has always been a small mystery, like nearly everything
else about his life.

It is commonly supposed (and frequently written) that
Shakespeare enjoyed a good education at the local grammar
school, King's New School, situated in the Guild Hall in
Church Street, and he probably did, though in fact we don't
know, as the school records for the period were long ago lost.
What is known is that the school was open to any local boy,
however dim or deficient, so long as he could read and write—
and William Shakespeare patently could do both. King's was
of an unusually high standard and was generously supported by
the town. The headmaster enjoyed an annual salary of twenty
pounds—roughly twice what was paid in other towns and even
more, it is often noted, than the headmaster at Eton got at the
time. The three masters at the school in Shakespeare's day were
all Oxford men—again a distinction.

Boys normally attended the school for seven or eight years,
beginning at the age of seven. The schoolday was long and char-
acterized by an extreme devotion to tedium. Pupils sat on hard
wooden benches from six in the morning to five or six in the
evening, with only two short pauses for refreshment, six days a

week. (The seventh day was probably given over largely to religious instruction.) For much of the year they can hardly have seen daylight. It is easy to understand the line in *As You Like It* about a boy "creeping like snail / Unwillingly to school."

Discipline was probably strict. A standard part of a teacher's training, as Stephen Greenblatt notes, was how to give a flogging. Yet compared with many private or boarding schools Stratford's grammar provided a cushioned existence. Boys at Westminster School in London had to sleep in a windowless grain storeroom, bereft of heat, and endure icy washes, meager food, and frequent whippings. (But then, these were conditions not unknown to many twentieth-century English schoolboys.) Their school day began at dawn as well but also incorporated an additional hour of lessons in the evening and private studies that kept some boys up late into the night.

Far from having "small Latin and less Greek," as Ben Jonson famously charged, Shakespeare had a great deal of Latin, for the life of a grammar-school boy was spent almost entirely in reading, writing, and reciting Latin, often in the most mind-numbingly repetitious manner. One of the principal texts of the day taught pupils 150 different ways of saying, "Thank you for your letter" in Latin. Through such exercises Shakespeare would have learned every possible rhetorical device and ploy—metaphor and anaphora, epistrophe and hyperbole, synecdoche, epanalepsis, and others equally arcane and taxing to memorize. According to Stanley Wells and Gary Taylor, in their introduction to the Oxford edition of the complete works, any grammar-school pupil of the day would have received a

more thorough grounding in Latin rhetoric and literature "than most present-day holders of a university degree in classics." But they wouldn't have received much else. Whatever mathematics, history, or geography Shakespeare knew, he almost certainly didn't learn it at grammar school.

Formal education stopped for Shakespeare probably when he was about fifteen. What became of him immediately after that is unknown—though many legends have rushed in to fill the vacuum. A particularly durable one is that he was caught poaching deer from the estate of Sir Thomas Lucy at Charlecote, just outside Stratford, and prudently elected to leave town in a hurry. The story and its attendant details are often repeated as fact even now. Roy Strong, in the scholarly *Tudor and Jacobean Portraits*, states that Shakespeare left Stratford in 1585 "to avoid prosecution for poaching at Charlecote" and that he was to be found in London the following year. In fact, we don't know when he left Stratford or arrived in London or whether he ever poached so much as an egg. It is, in any case, unlikely that he poached deer from Charlecote, as it didn't have a deer park until the following century.

The only certainty we possess for this early period of Shakespeare's adulthood is that in late November 1582, a clerk at Worcester recorded that William Shakespeare had applied for a license to marry. The bride, according to the ledger, was not Anne Hathaway but Anne Whateley of nearby Temple Grafton—a mystery that has led some biographers to suggest that Shakespeare courted two women to the point of matrimony at the same time and that he stood up Anne Whateley out of

duty to the pregnant Anne Hathaway. Anthony Burgess, in a slightly fevered moment, suggested that young Will, "sent on skin-buying errands to Temple Grafton," perhaps fell for "a comely daughter, sweet as May and shy as a fawn."

In fact Anne Whateley probably never existed. In four hundred years of searching, no other record of her has ever been found. The clerk at Worcester was not, it appears, the most meticulous of record keepers. Elsewhere in the ledgers, in the same hand, scholars have found "Barbar" recorded as "Baker," "Edgcock" confused with "Elcock," and "Darby" put in place of "Bradeley," so turning Hathaway into Whateley was by no means beyond his wayward capabilities. Moreover—for Shakespeare investigators really are tireless—the records also show that in another book on the same day the clerk noted a suit concerning a William Whateley, and it is presumed that the name somehow stuck in his mind. No one, however, has yet found a convincing explanation for how Temple Grafton came into the records when the real bride was from Shottery.

The marriage license itself is lost, but a separate document, the marriage bond, survives. On it Anne Hathaway is correctly identified. Shakespeare's name is rendered as "Shagspere"—the first of many arrestingly variable renderings. The marriage bond cost £40 and permitted the marriage to proceed with one reading of the banns instead of the normal three so that it might be conducted the sooner. The £40 was to indemnify the church authorities against any costly suits arising from the action—a claim of breach of promise, for instance. It was a truly whopping sum—something like £20,000 in today's

money—particularly when one's father is so indebted that he can barely leave his own house for fear of arrest and imprisonment. Clearly there was much urgency to get the couple wed.

What makes this slightly puzzling is that it was not unusual for a bride to be pregnant on her wedding day. Up to 40 percent of brides were in that state, according to one calculation, so why the extravagant haste here is a matter that can only be guessed at. It *was* unusual, however, for a young man to be married at eighteen, as Shakespeare was. Men tended to marry in their mid- to late twenties, women a little sooner. But these figures were extremely variable. Christopher Marlowe had a sister who married at twelve (and died at thirteen in childbirth). Until 1604 the age of consent was twelve for a girl, fourteen for a boy.

We know precious little about Shakespeare's wife and nothing at all about her temperament, intelligence, religious views, or other personal qualities. We are not even sure that Anne was her usual name. In her father's will she was referred to as Agnes (which at the time was pronounced with a silent *g*, making it "ANN-uss"). "Agnes" and "Anne" were often treated as interchangeable names. We know also that she was one of seven children and that she evidently came from prosperous stock: Though her childhood home is always referred to as Anne Hathaway's cottage, it was (and is) a handsome and substantial property, containing twelve rooms. Her gravestone describes her as being sixty-seven years old at the time of her death in 1623. It is from this alone that we conclude that she was considerably older than her husband. Apart from the gravestone, there is no evidence of her age on record.

We know also that she had three children with William Shakespeare—Susanna in May 1583 and the twins, Judith and Hamnet, in early February 1585—but all the rest is darkness. We know nothing about the couple's relationship—whether they bickered constantly or were eternally doting. We don't know if she ever accompanied him to London, saw any of his plays, or even took an interest in them. We have no indication of any warmth between them—but then we have no indication of warmth between William Shakespeare and any other human being. It is tempting to suppose that they had some sort of real bond for at least the first years of their marriage—they had children together on two occasions, after all—but it may actually be, for all we know, that they were very loving indeed and enjoyed a continuing (if presumably often long-distance) affection throughout their marriage. Two of the few certainties of Shakespeare's life are that his marriage lasted till his death and that he sent much of his wealth back to Stratford as soon as he was able, which may not be conclusive proof of attachment but hardly argues against it.

So, in any case, we have the position of a William Shakespeare who was poor, at the head of a growing family, and not yet twenty-one—not the most promising of situations for a young man with ambitions. Yet somehow from these most unpropitious circumstances he became a notable success in a competitive and challenging profession in a distant city in seemingly no time at all. How he did it is a perennial mystery.

One possibility is often mentioned. In 1587, when Shakespeare was twenty-three, an incident occurred among the

Queen's Men, one of the leading acting troupes, that may have provided an opening for Shakespeare. Specifically, while touring the provinces, the company was stopped at Thame, a riverside town in Oxfordshire, when a fight broke out between William Knell, one of the company's leading men, and another actor, John Towne. In the course of their fight, Towne stabbed Knell through the neck, mortally wounding him (though evidently in self-defense, as he was subsequently cleared of blame). Knell's death left the company an actor short and raised the possibility that they recruited or were joined by a stagestruck young William Shakespeare when they passed through Stratford. Unfortunately there is no documentary evidence to connect Shakespeare to the Queen's Men at any stage of his career, and we don't know whether the troupe visited Stratford before or after its fateful stop in Thame.

There is, however, an additional intriguing note in all this. Less than a year later Knell's youthful widow, Rebecca, who was only fifteen or sixteen, remarried. Her new partner was John Heminges, who would become one of Shakespeare's closest friends and associates and who would, with Henry Condell, put together the First Folio of Shakespeare's works after Shakespeare's death.

But a few intriguing notes are all that the record can offer. It is extraordinary to think that before he settled in London and became celebrated as a playwright, history provides just four recorded glimpses of Shakespeare—at his baptism, his wedding, and the two births of his children. There is also a passing reference to him in a lawsuit of 1588 filed by his father

in a property dispute, but that has nothing to say about where he was at that time or what he was doing.

Shakespeare's early life is really little more than a series of occasional sightings. So when we note that he was now about to embark on what are popularly known as his lost years, they are very lost indeed.

Chapter Three

The Lost Years, 1585–1592

FEW PLACES IN HISTORY can have been more deadly and desirable at the same time than London in the sixteenth century. Conditions that made life challenging elsewhere were particularly rife in London, where newly arrived sailors and other travelers continually refreshed the city's stock of infectious maladies.

Plague, virtually always present somewhere in the city, flared murderously every ten years or so. Those who could afford to left the cities at every outbreak. This in large part was the reason for the number of royal palaces just outside London—at Richmond, Greenwich, Hampton Court, and elsewhere. Public performances of all types—in fact all public gatherings except for churchgoing—were also banned within seven miles of London each time the death toll in the city reached forty, and that happened a great deal.

In nearly every year for at least 250 years, deaths outnum-

bered births in London. Only the steady influx of ambitious provincials and Protestant refugees from the Continent kept the population growing—and grow it did, from fifty thousand in 1500 to four times that number by century's end. (Such figures are of course estimates.) By the peak years of Elizabeth's reign, London was one of the great cities of Europe, exceeded in size only by Paris and Naples. In Britain no other place even came close to rivaling it. A single London district like Southwark had more people than Norwich, England's second city. But survival was ever a struggle. Nowhere in the metropolis did life expectancy exceed thirty-five years, and in some poorer districts it was barely twenty-five. The London that William Shakespeare first encountered was overwhelmingly a youthful place.

The bulk of the population was packed into 448 exceedingly cozy acres within the city walls around the Tower of London and Saint Paul's Cathedral. The walls survive today only in scattered fragments and relic names—notably those of its gateways: Bishopsgate, Cripplegate, Newgate, Aldgate, and so on—but the area they once physically bounded is still known as the City of London and remains administratively aloof from the much vaster, but crucially lowercased, city of London that surrounds it.

In Shakespeare's day the City was divided into a hundred or so parishes, many of them tiny, as all the proximate spires in the district attest even today (even when there are far fewer churches than in Shakespeare's time). The number varied slightly over time as parishes sometimes amalgamated, creat-

ing such mellifluous entities as "Saint Andrew Undershaft with All Hallows on the Wall" and "Saint Stephen Walbrook and Saint Benet Sheerhogg with Saint Laurence Pountney." It is a striking reflection of the importance of religion to the age that within such a snug ambit there existed scores of parish churches *and* a mighty cathedral, Saint Paul's, not to mention the nearby abbey at Westminster and the noble stone mount of Saint Mary Overie (now Southwark Cathedral) just across the river.

By modern standards the whole of greater London, including Southwark and Westminster, was small. It stretched only about two miles from north to south and three from east to west, and could be crossed on foot in not much more than an hour. But to an impressionable young provincial like William Shakespeare the clamor and clutter and endless jostle, the thought that any glimpsed face would in all likelihood never be seen again, must have made it seem illimitable. This was, after all, a city where a single theater held more people than his hometown.

In Shakespeare's day the walls were still largely intact, though often difficult to discern because so many buildings were propped against them. Beyond the walls the fields were rapidly filling in. In his great and stately *Survey of London*, published in 1598, when he was in his seventies, John Stow noted with dismay how many districts that had formerly looked out on open fields where people could "refresh their dull spirits in the sweet and wholesome air" now gave way to vast encampments of smoky hovels and workshops. (In a touching reminder of the timelessness of complaint, he also bemoaned the fact that

traffic in the city had grown impossible and that the young never walked.)*

London's growth was limited only by unsuitable conditions for building. Heavy clay soils to the north of the city made it nearly impossible to sink wells or provide adequate drainage, so the northern outskirts remained rural far longer. On the whole, however, growth was unrelenting. The authorities repeatedly issued edicts that new housing was not to be erected within three miles of City walls, under pain of demolition, but the fact that the edicts had so often to be renewed shows how little they were regarded. The one effect the laws *did* have was to discourage the erecting of buildings of quality outside the City walls, since they might at any moment be condemned. Instead London became increasingly ringed with slums.

Most of the districts that we think of now as integral parts of London—Chelsea, Hampstead, Hammersmith, and so on—were then quite separate, and in practical terms often quite distant, villages. Westminster, the seat of government, was a separate city, dominated by Westminster Abbey and Whitehall Palace, a twenty-three-acre complex of royal apartments, offices, storehouses, cockpits, tennis courts, tiltyards,

* A tailor by profession, Stow spent a lifetime and endured decades of poverty to put together his great history. He was seventy-three when it was published. His payment was £3 in cash and forty copies of his own book. When James I was asked to provide some charitable patronage for the old man, he merely sent him two letters giving him permission to beg. Stow actually did so, setting up alms bowls in the streets of the City, though without much effect.

and much else, bounded by several hundred acres of hunting grounds, which today survive in remnants as London's great central parks: Hyde Park and Kensington Gardens, Green Park, Saint James's Park, and Regent's Park.

With 1,500 rooms and a resident population of a thousand or so courtiers, servants, bureaucrats, and hangers-on, Westminster was the largest and busiest palace in Europe and headquarters for the English monarch and her government—though Elizabeth, like her father before her, used it only as a winter residence. Shakespeare would get to know at least part of the palace well, as player and playwright. Every bit of the historic palace is now gone except the Banqueting House, and Shakespeare never saw that, for the present building was built in 1619, after he died.

City life had a density and coziness that we can scarcely imagine now. Away from the few main thoroughfares, streets were much narrower than they are now, and houses, with their projecting upper floors, often all but touched. So neighbors were close indeed, and all the stench and effluvia that they produced tended to accumulate and linger. Refuse was a perennial problem. (Houndsditch, according to John Stow, got its name from the number of dogs thrown into it; even if fanciful the story is telling.) Rich and poor lived far more side by side than now. The playwright Robert Greene died in wretched squalor in a tenement in Dowgate, near London Bridge, only a few doors from the home of Sir Francis Drake, one of the wealthiest men in the land.

According to nearly all histories, the gates to the City were

locked at dusk, and no one was allowed in or out till dawn, though as dusk falls at midafternoon in a London winter there must have been some discretion in the law's application or there would have been, at the very least, crowds of stranded, and presumably aggrieved, playgoers on most days of the week. Movement was only fractionally less proscribed, at least in theory, inside the walls. A curfew took effect with darkness, at which time taverns were shut and citizens forbidden to be out, though the fact that the night constables and watchmen were nearly always portrayed in the theater as laughable dimwits (think of Dogberry in *Much Ado About Nothing*) suggests that they were not regarded with much fear.

The principal geographical feature of the city was the Thames. Unconstrained by artificial embankments, the river sprawled where it could. It was up to a thousand feet wide in places—much wider than it is today—and was the main artery for the movement of both goods and people, though the one span across it, London Bridge, stood as an unnerving impediment to through traffic. Because water accelerates as it flows through narrow openings, "shooting the bridge" was an exciting and risky adventure. A popular saying had it that London Bridge was made for wise men to pass over and fools to pass under. Despite all that was tipped into it, the river was remarkably full of life. Flounder, shrimp, bream, barbels, trout, dace, eels, and even occasionally swordfish, porpoises, and other exotica were among the catches hauled out by bemused or startled fishermen. On one memorable occasion, a whale nearly got caught between the arches of London Bridge.

The bridge was already venerable when Shakespeare first saw it. It had been built nearly four centuries earlier, in 1209, and would remain the only span across the river in London for nearly two centuries more. Standing a little east of today's London Bridge, it stretched more than nine hundred feet and was a little city in itself, with more than a hundred shops in scores of buildings of all shapes and sizes. The bridge was the noisiest place in the metropolis, but also the cleanest (or at least the best aired), and so became an outpost of wealthy merchants—a kind of sixteenth-century Bond Street. Because space was so valuable, some of the buildings were six stories high and projected as much as sixty-five feet over the river, supported by mighty struts and groaning buttresses. It even had its own precarious palace, Nonesuch House, built in the late 1570s, teetering at its southern end.

By long tradition at the Southwark end of the bridge the heads of serious criminals, especially traitors, were displayed on poles, each serving as a kind of odd and grisly bird feeder. (The headless bodies were hung above the entrance gates to the city, or distributed to other cities across the realm.) There were so many heads, indeed, that it was necessary to employ a Keeper of the Heads. Shakespeare, arriving in London, was possibly greeted by the heads of two of his own distant kinsmen, John Somerville and Edward Arden, who were executed in 1583 for a fumbling plot to kill the queen.

The other dominant structure in the city was old Saint Paul's Cathedral, which was even larger than the one we see today, though its profile was oddly stunted. A steeple that had

once pierced the sky to a height of five hundred feet had been lost to lightning just before Shakespeare was born and never replaced. The cathedral that Elizabethans knew would vanish in the Great Fire of 1666, a generation or so in the future, making way for the stately white Christopher Wren edifice we see today.

Saint Paul's stood in an immense open square, covering about twelve acres all together, which served, a bit unexpectedly, as both cemetery and market. It was filled on most days with the stalls of printers and stationers, a sight that must have been hypnotizing for a young man with an instinctive regard for words. Printed books had already existed, as luxuries, for a century, but this was the age in which they first became accessible to anyone with a little spare income. At last average people could acquire learning and sophistication on demand. More than seven thousand titles were published in London in Elizabeth's reign—a bounty of raw materials waiting to be absorbed, reworked, or otherwise exploited by a generation of playwrights experimenting with entirely new ways of entertaining the public. This was the world into which Shakespeare strode, primed and gifted. He must have thought he'd found very heaven.

Inside, the cathedral was an infinitely noisier and more public place than we find today. Carpenters, bookbinders, scriveners, lawyers, haulers, and others all plied their trades within its echoing vastness, even during services. Drunks and vagrants used it is as a place of repose; some relieved themselves in corners. Little boys played ball games in the aisles until chased away. Other people made small fires to keep warm. John

Evelyn could have been writing of Saint Paul's when he noted, a generation later, "I have been in a spacious church where I could not discern the minister for the smoke; nor hear him for the people's barking."

Many used the building as a shortcut, particularly when it rained. The desire to retire indoors was motivated by fashion as much as any sudden interest in comfort. Starch, a stylish new item just making its way into England from France, notoriously wilted in rain. Starch's possibilities for fashionable discomfort were already being translated into increasingly exotic ruffs, soon to be known as *piccadills* (or *peckadills*, *pickadailles*, *picardillos*, or any of about twenty other variants), from which ultimately would come the name "Piccadilly," and these grew "every day worser and worser" as one contemporary glumly noted.* Moreover, dyes were not yet colorfast, or even close to it, adding a further powerful incentive to stay dry.

Partly for this reason Sir Thomas Gresham had recently built the Royal Exchange, the most fabulous commercial building of its day. (Gresham is traditionally associated with Gresham's law—that bad money drives out good—which he may or may not actually have formulated.) Modeled on the Bourse in Antwerp, the Exchange contained 150 small shops, making it one

* The word *piccadill* was first recorded by the playwright Thomas Dekker in 1607 in *Northward Ho*. Eventually a house near the modern Trafalgar Square became informally but popularly known as Piccadilly Hall, possibly because its owner made his money selling piccadills. The street running west toward Hyde Park took its name from the hall, not the ruffs.

of the world's first shopping malls, but its primary purpose and virtue was that for the first time it allowed City merchants—some four thousand of them—to conduct their business indoors out of the rain. We may marvel that they waited so long to escape the English weather, but there we are.

Among other differences we would notice between then and now was much to do with dining and diet. The main meal was taken at midday and, among the better off, often featured foods that are uneaten now—crane, bustard, swan, and stork, for instance. Those who ate well ate at least as well as people today. A contemporary of Shakespeare's (and a friend of the family) named Elinor Fettiplace left to posterity a household management book from 1604—one of the first of its type to survive—that contains recipes for any number of dishes of delicacy and invention: mutton with claret and Seville orange juice, spinach tart, cheesecakes, custards, creamy meringues.* Other contemporary accounts—not least the plays of Shakespeare and his fellow writers—show an appreciation for dietary variety that many of us would be pressed to match today.

For poorer people, not surprisingly, diet was much simpler and more monotonous, consisting mainly of dark bread and

* Fettiplace's book is a gossipy, wide-ranging compendium of recipes, cleaning tips, and other domestic concerns gathered from relatives and friends. Among these friends was John Hall, Shakespeare's son-in-law. So it is entirely possible that she knew the playwright himself; she must certainly have known of him. But if she had any idea of his importance to posterity, or how grateful we would be for even the slightest word of his character and appetites, she failed to note it in her household accounts.

cheese, with a little occasional meat. Vegetables were eaten mostly by those who could afford nothing better. The potato was an exotic newcomer, still treated skeptically by many because its leaves looked similar to those of poisonous nightshade. Potatoes wouldn't become a popular food until the eighteenth century. Tea and coffee were yet unknown.

People of all classes loved their foods sweet. Many dishes were coated with sticky sweet glazes, and even wine was sometimes given a generous charge of sugar, as were fish, eggs, and meats of every type. Such was the popularity of sugar that people's teeth often turned black, and those who failed to attain the condition naturally sometimes blackened their teeth artificially to show that they had had their share of sugar, too. Rich women, including the queen, made themselves additionally beauteous by bleaching their skin with compounds of borax, sulfur, and lead—all at least mildly toxic, sometimes very much more so—for pale skin was a sign of supreme loveliness. (Which makes the "dark lady" of Shakespeare's sonnets an exotic being in the extreme.)

Beer was drunk copiously, even at breakfast and even by the pleasure-wary Puritans. (The ship that took the Puritan leader John Winthrop to New England carried him, ten thousand gallons of beer, and not much else.) A gallon a day was the traditional ration for monks, and we may assume that most others drank no less. For foreigners English ale was an acquired taste even then. As one continental visitor noted uneasily, it was "cloudy like horse's urine." The better off drank wine, generally by the pint.

Tobacco, introduced to London the year after Shakespeare's birth, was a luxury at first but soon gained such widespread popularity that by the end of the century there were no fewer than seven thousand tobacconists in the City. It was employed not only for pleasure but as a treatment for a broad range of complaints, including venereal disease, migraine, and even bad breath, and was seen as such a reliable prophylactic against plague that even small children were encouraged to use it. For a time pupils at Eton faced a beating if caught neglecting their tobacco.

Criminality was so widespread that its practitioners split into fields of specialization. Some became *coney catchers*, or swindlers (a coney was a rabbit reared for the table and thus unsuspectingly tame); others became *foists* (pickpockets), *nips*, or *nippers* (cutpurses), *hookers* (who snatched desirables through open windows with hooks), *abtams* (who feigned lunacy to provide a distraction), *whipjacks*, *fingerers*, *cross biters*, *cozeners*, *courtesy men*, and many more. Brawls were shockingly common. Even poets carried arms. An actor named Gabriel Spencer killed a man named James Freake in a duel, then in turn was killed by Ben Jonson two years later. Christopher Marlowe was involved in at least two fatal fights, one in which he helped a colleague kill a young innkeeper and another in which he was killed in a drunken scuffle in Deptford.

We don't know when Shakespeare first came to London. Ever a shadow even in his own biography, he disappears, all but utterly, from 1585 to 1592, the very years we would most like to know where he was and what he was up to, for it was in this

period that he left Stratford (and, presumably, wife and family) and established himself as an actor and playwright. There is not a more tempting void in literary history, nor more eager hands to fill it.

Among the first to try was John Aubrey, who reported in 1681, long after Shakespeare was dead, that he was a school-master in the country, but no evidence has ever been presented to support the claim. Various other suggestions for the lost years have him traveling in Italy, passing his time as a soldier in Flanders, or going to sea—possibly, in the more romantic versions, sailing with Drake on the *Golden Hinde*. Generally none of this is based on anything other than a need to put him *somewhere* and a desire to explain some preoccupation or area of expertise that later became evident in his work.

It is often noted, for instance, that Shakespeare's plays are full of ocean metaphors ("take arms against a sea of troubles," "an ocean of salt tears," "wild sea of my conscience") and that every one of his plays has at least one reference to the sea in it somewhere. But the idea that this argues for a maritime spell in his life shrivels slightly when you realize that *sailor* appears just four times in his work and *seamen* only twice. Moreover, as Caroline Spurgeon long ago noted, Shakespeare's marine al-lusions mostly depict the sea as a hostile and forbidding en-vironment, a place of storms and shipwrecks and unsettling depths—precisely the perspective one would expect from someone who wasn't comfortably acquainted with it. In any case there is an obvious danger in reading too much into word frequencies. Shakespeare refers to Italy in his work more often

than to Scotland (35 times to 28) and to France far more than to England (369 references to 243), but we would hardly suppose him French or Italian.

One possibility for how Shakespeare spent these missing years, embraced with enthusiasm by some scholars, is that he didn't come to London by any direct route, but rather went to northern England, to Lancashire, as a recusant Catholic. The idea was first put forward as long ago as 1937 but has gained momentum in recent years. As it now stands it is a complicated and ingenious theory based (as I believe its proponents would freely enough concede) on a good deal of supposition. The gist of it is that Shakespeare may have passed his time in the north as a tutor and possibly as an actor (we must, after all, get him ready for a theatrical career soon afterward), and that the people responsible for this were Roman Catholics.

There is certainly no shortage of possible Catholic connections. Throughout Shakespeare's early years, some four hundred English-born, French-trained Jesuit missionaries were slipped into England to offer illicit religious services to Catholics, often in large secret gatherings on Catholic estates. It was dangerous work. About a quarter of the missionaries were caught and dreadfully executed, though others were simply rounded up and sent back to France. Those who escaped capture, or were brave enough to return and try again, often worked exceedingly productively. Robert Parsons and Edmund Campion between them were said to have converted (or reconverted) twenty thousand people on a single tour.

In 1580, when William was sixteen, Campion passed

through Warwickshire on his way to the more safely Catholic north. He stayed with a distant relative of Shakespeare's, Sir William Catesby, whose son Robert would later be a ringleader of the Gunpowder Plot. One of the masters at Shakespeare's school during his time there (always assuming he *was* there) was John Cottom, who came from a prominent Catholic family in Lancashire and whose brother was a missionary priest closely associated with Campion. In 1582 this latter Cottom was caught, tortured, and put to death, along with Campion himself. Meanwhile his older brother, the schoolmaster, had left Stratford—whether in a hurry or not is unknown—and returned to Lancashire, where he declared his Catholicism openly.

The thought is that this Cottom may have taken Will with him. What adds appeal to the theory is that the following year a "William Shakeshafte" appears in the household accounts of Alexander Hoghton, a prominent Catholic living just ten miles from the Cottom family seat. Moreover Hoghton in his will commended this Shakeshafte to a fellow Catholic and landowner, Thomas Hesketh, as someone worth employing. In the same passage Hoghton also mentioned the disposition of his musical instruments and "play clothes," or costumes. "This sequence," notes the Shakespeare authority Robert Bearman, "suggests that this Shakeshafte was either a household musician or player or both."

According to one version of the theory, Shakespeare, on the strength of Hoghton's endorsement, moved to the Hesketh family seat, at Rufford, and there encountered traveling troupes of play-

ers, such as Lord Derby's Men, through which he made a connection that took him to London and a life in the theater. Interestingly one of Shakespeare's later business associates, a goldsmith named Thomas Savage, who served as a trustee for the leasehold on the Globe, was also from Rufford and related by marriage to the Hesketh family. So the coincidences are intriguing.

However, it must be said that one or two troubling considerations need to be accounted for in all this. First, there is the problem that William Shakeshafte received an unusually large annuity of two pounds in Hoghton's will—more than any other member of the household but one. That would be a generous gift indeed, bearing in mind that our William Shakespeare was just seventeen years old and could have been in Hoghton's employ for only a few months at the time of the latter's death. It seems more likely, on the face of it, that such a bequest would go to a longer-serving, and no doubt more elderly, employee, as a kind of pension.

There is also the curious matter of the name. "Shakeshafte" is clearly not an ingenious alias. Some scholars maintain that "Shakeshafte" was simply a northern variant of "Shakespeare," and that our Will wasn't trying to hide his name but merely to adapt it. This may be so but it suggests a further reason for uncertainty. "Shakeshafte" was not an uncommon name in Lancashire. In 1582 the records show seven Shakeshafte households in the area, of which at least three had members named William. So it requires a certain leap of faith to suppose with any confidence that this one was the young Will from Stratford. As Frank Kermode succinctly summed up the Catholic issue

(in the *New York Times Book Review*), "There seems to be no reason whatever to believe this except the pressure of a keen desire for it to be true."

In addition to all this there is the problem of allowing Shakespeare time enough for both a Lancashire adventure and a return to Stratford to woo and bed Anne Hathaway. Shakespeare's first child, Susanna, was baptized in May 1583, indicating conception the previous August—at just about the time he is supposed to have been in Lancashire. It is not impossible that William Shakespeare could have been a Catholic in Lancashire and a suitor to Anne Hathaway at more or less the same time—as well as a budding theatrical figure—but one may reasonably ask if that isn't supposing rather a lot.

It is impossible to say how religious Shakespeare was, or if he was at all. The evidence, predictably, is mixed. Samuel Schoenbaum was struck by how often certain biblical allusions appeared in Shakespeare's work; the story of Cain, for instance, appears twenty-five times in thirty-eight plays—quite a high proportion. But Otto Jespersen and Caroline Spurgeon thought Shakespeare almost wholly *un*interested in biblical themes, and noted that nowhere in his works did the words "Bible," "Trinity" or "Holy Ghost" appear—a conclusion endorsed in more recent times by the British historian Richard Jenkyns. "The more Elizabethan literature one reads," he has written, "the more striking is Shakespeare's paucity of religious reference." The British authority Stanley Wells, however, contends that Shakespeare's plays "are riddled with biblical allusions."

In short, and as always, a devoted reader can find support for nearly any position he or she wishes in Shakespeare. (Or as Shakespeare himself put it in a much misquoted line: "The devil can cite Scripture for his purpose.") As Professor Harry Levin of Harvard has noted, Shakespeare condemned suicide in plays like *Hamlet*, where it would conflict with sixteenth-century Christian dogma, but treated it as ennobling in his Roman and Egyptian plays, where it was appropriate (and safe) to suggest as much. From what little is known, and whatever their private thoughts may have been, it is certainly the case from their marriages, christenings, and so on that John Shakespeare and William gave every appearance of being dutiful, if not necessarily pious, Protestants.

David Thomas of the National Archives thinks it unlikely in any case that a definitive answer will ever emerge as to whether Shakespeare passed his lost period in Lancashire, as a Catholic or otherwise. "Unless he got married or had children there, or bought property or paid taxes—and people at his level at that time didn't pay taxes—or committed a crime or sued someone, he wouldn't appear in the record. As far as we know, he didn't do any of those things." Instead the only proof of Shakespeare's existence we have for the period is a passing reference to him on a legal document, which gives no indication of his occupation or whereabouts.

Tensions between Protestants and Catholics came to a head in 1586 when Mary, Queen of Scots, was implicated in a plot to overthrow the queen and Elizabeth agreed, reluctantly, that she

must be executed. Killing a fellow monarch, however threaten-
ing, was a grave act, and it provoked a response. In the spring of
the following year, Spain dispatched a mighty navy to capture
the English throne and replace Elizabeth.

The greatest fleet that "ever swam upon the sea," the
Spanish Armada looked invincible. In battle formation it
spread over seven miles of sea and carried ferocious firepower:
123,000 cannonballs and nearly three thousand cannons, plus
every manner of musket and small arms, divided between
thirty thousand men. The Spanish confidently expected the
swiftest of triumphs—one literally for the glory of God. Once
England fell, and with the English fleet in Spanish hands,
the very real prospect arose of the whole of Protestant Europe
being toppled.

Things didn't go to plan, to put it mildly. England's ships
were nimbler and sat lower in the water, making them awkward
targets. They could dart about doing damage here and there
while the Spanish guns, standing on high decks, mostly fired
above them. The English ships were better commanded, too (or
so all English history books tell us). It is only fair to note that
most vessels of the Spanish fleet were not battleships but over-
loaded troop carriers, making plump and lumbering targets.
The English also enjoyed a crucial territorial edge: They could
exploit their intimate knowledge of local tides and currents,
and could dart back to the warm comfort of home ports for
refreshment and repairs. Above all they had a decisive techno-
logical advantage: cast-iron cannons, an English invention that
other nations had not yet perfected, which fired straighter and

were vastly sturdier than the Spanish bronze guns, which were poorly bored and inaccurate and had to be allowed to cool after every two or three rounds. Crews that failed to heed this—and in the heat of battle it was easy to lose track—often blew themselves up. In any case the Spanish barely trained their gun crews. Their strategy was to come alongside and board enemy ships, capturing them in hand-to-hand combat.

The rout was spectacular. It took the English just three weeks to pick the opponent's navy to pieces. In a single day the Spanish suffered eight thousand casualties. Dismayed and confused, the tattered fleet fled up the east coast of England and around Scotland into the Irish Sea, where fate dealt it further cruel blows in the form of lashing gales, which wrecked at least two dozen ships. A thousand Spanish bodies, it was recorded, washed up on Irish beaches. Those who struggled ashore were often slaughtered for their baubles. By the time the remnants of the Armada limped home, it had lost seventeen thousand men out of the thirty thousand who had set off. England lost no ships at all.

The defeat of the Spanish Armada changed the course of history. It induced a rush of patriotism in England that Shakespeare exploited in his history plays (nearly all written in the following decade), and it gave England the confidence and power to command the seas and build a global empire, beginning almost immediately with North America. Above all it secured Protestantism for England. Had the Armada prevailed, it would have brought with it the Spanish Inquisition, with goodness knows what consequences for Elizabethan Eng-

land—and the young man from Warwickshire who was just about to transform its theater.

There is an interesting postscript to this. A century and a half after John Shakespeare's death, workmen rooting around in the rafters of the Shakespeare family home on Henley Street in Stratford found a written testament—a "Last Will of the Soul," as it was called—declaring John's adherence to the Catholic faith. It was a formal declaration of a type known to have been smuggled into England by Edmund Campion.

Scholars have debated ever since whether the document itself was genuine, whether John Shakespeare's signature upon it was genuine, and what any of this might or might not imply about the religious beliefs of William Shakespeare. The first two of these questions are likely to remain forever unresolvable as the document was lost sometime after its discovery, and the third could never be other than a matter of conjecture anyway.

Chapter Four

In London

IN 1596, WHILE ATTENDING a performance at the new Swan Theatre in London, a Dutch tourist named Johannes de Witt did a very useful thing that no one, it seems, had ever done before. He made a sketch—rather rough and with a not wholly convincing grasp of perspective—depicting the Swan's interior as viewed from a central seat in the upper galleries. The sketch shows a large projecting stage, partly roofed, with a tower behind containing a space known as the tiring (short for "attiring") house—a term whose earliest recorded use is by William Shakespeare in *A Midsummer Night's Dream*—where the actors changed costumes and grabbed props. Above the tiring area were galleries for musicians and audience, as well as spaces that could be incorporated into performances, for balcony scenes and the like. The whole bears a striking resemblance to the interior of the replica Globe Theatre we find on London's Bankside today.

De Witt's little effort was subsequently lost, but luckily a friend of his had made a faithful copy in a notebook, and this eventually found its way into the archives of the library of the University of Utrecht in the Netherlands. There it sat unregarded for almost three hundred years. But in 1888 a German named Karl Gaedertz found the notebook and its rough sketch, and luckily—all but miraculously—recognized its significance, for the sketch represents the only known visual depiction of the interior of an Elizabethan playhouse in London. Without it we would know essentially nothing about the working layout of theaters of the time. Its uniqueness explains the similarity of the interior design of the new, replica Globe. It was all there was to go on.

Two decades after de Witt's visit, another Dutchman, an artist named Claes Jan Visscher, produced a famous engraved panorama of London, showing in the foreground the theaters of Bankside, the Globe among them. Roughly circular and with a thatched roof, this was very much Shakespeare's "wooden O" and has remained the default image of the theater ever since. However, in 1948, a scholar named I. A. Shapiro showed pretty well conclusively that Visscher had based his drawing on an earlier engraving, from 1572, before any of the theaters he depicted had actually been built. In fact, it appeared that Visscher had never actually been to London and so was hardly the most reliable of witnesses.

This left just one illustration from the era known to have been drawn from life and that was a view made by a Bohemian artist named Wenceslas Hollar sometime in the late 1630s or

early 1640s. Called the *Long View*, it is a lovely drawing—"perhaps the most beautiful and harmonious of all London panoramas," in Peter Ackroyd's estimation—but a slightly strange one in that it depicts a view from a position slightly above and behind the tower of Southwark Cathedral (then known as the Church of Saint Saviour and Saint Mary Overie), as if Hollar had been looking down on the cathedral from another building—a building that did not in fact exist.

So it is a view—entirely accurate as far as can be made out—that no human had ever seen. More to the point, it showed the second Globe, not the first, which had burned down in 1613, three years before Shakespeare died. The second Globe was a fine theater, and we are lucky to have Hollar's drawing of it, for it was pulled down soon afterward, but it was patently not the place where *Julius Caesar*, *Macbeth*, and a dozen or so other Shakespeare plays were (probably to almost certainly) first performed. In any case the Globe was only a very small part of the whole composition and was depicted as seen from a distance of nine hundred feet, so it offers very little detail.

And there you have the complete visual record we possess of theaters in Shakespeare's day and somewhat beyond: one rough sketch of the interior of a playhouse Shakespeare had no connection with, one doubtful panorama by someone who may never have seen London, and one depiction done years after Shakespeare left the scene showing a theater he never wrote for. The best that can be said of any of them is that they may bear some resemblance to the playhouses Shakespeare knew, but possibly not.

The written record for the period is not a great deal more enlightening. Most of what little we know about what it was like to attend the theater in Shakespeare's time comes from the letters and diaries of tourists, for whom the London sights were novel enough to be worth recording. Sometimes, however, it is a little hard to know quite what to make of these. In 1587 a visitor from the country wrote excitedly to his father about an unexpected event he had seen at a performance by the Admiral's Men: One actor had raised a musket to fire at another, but the musket ball "missed the fellow he aimed at and killed a child, and a woman great with child forthwith, and hit another man in the head very sore." It is astounding to suppose that actors were firing live muskets—which in the sixteenth century were really little more than exploding sticks—in the confined space of a theater, but, if so, one wonders where they were hoping the musket ball *would* lodge. The Admiral's Men failed to secure an invitation to take part in the Christmas revels at court the following month—something that would normally have been more or less automatic—so it would appear that they were in some sort of temporary disgrace.

We would know even less about the business and structure of Elizabethan theatrical life were it not for the diary and related papers of Philip Henslowe, proprietor of the Rose and Fortune theaters. Henslowe was a man of many parts, not all of them entirely commendable. He was an impresario, moneylender, property investor, timber merchant, dyer, starch manufacturer, and, in a very big way, brothel keeper, among much else. He was famous among writers for advancing them small

sums, then keeping them in a kind of measured penury, the better to coax plays from them. But for all his shortcomings, Henslowe redeemed himself to history by keeping meticulous records, of which those from the years 1592 to 1603 survive. His "diary," as it is usually called, wasn't really a diary so much as a catchall of preoccupations; it included a recipe for curing deafness, notes on casting spells, even advice on how best to pasture a horse. But it also incorporated invaluable details of the day-to-day running of a playhouse, including the names of plays his company performed and the actors employed, along with exhaustive lists of stage props and wardrobes (including a delightfully mysterious "robe for to go invisible").

Henslowe's papers also included a detailed contract for the building of the Fortune Theatre, at an agreed-on cost of £440, in 1600. Although the Fortune was not much like the Globe— it was somewhat larger, and square rather than round—and although the contract included no drawings, it provided specifications on the heights and depths of the galleries, the thickness of wood to be used in the floors, the composition of plaster in the walls, and other details that proved immeasurably beneficial in building the replica Globe on Bankside in 1997.

Theaters as dedicated spaces of entertainment were a new phenomenon in England in Shakespeare's lifetime. Previously players had performed in innyards or the halls of great homes or other spaces normally used for other purposes. London's first true playhouse appears to have been the Red Lion, built in 1567 in Whitechapel by an entrepreneur named John Brayne. Almost nothing is known about the Red Lion, includ-

ing how much success it enjoyed, but its life appears to have been short. Still, it must have shown some promise, for nine years after its construction Brayne was at it again, this time working in league with his brother-in-law, James Burbage, who was a carpenter by trade but an actor and impresario by nature. Their new theater—called the Theatre—opened in 1576 a few hundred yards to the north of the City walls near Finsbury Fields in Shoreditch. Soon afterward Burbage's longtime rival Henslowe opened the Curtain Theatre just up the road, and London was a truly theatrical place.

William Shakespeare could not have chosen a more propitious moment to come of age. By the time he arrived in London in (presumably) the late 1580s, theaters dotted the outskirts and would continue to rise throughout his career. All were compelled to reside in "liberties," areas mostly outside London's walls where City laws and regulations did not apply. It was a banishment they shared with brothels, prisons, gunpowder stores, unconsecrated graveyards, lunatic asylums (the notorious Bedlam stood close by the Theatre), and noisome enterprises like soapmaking, dyeing, and tanning—and these could be noisome indeed. Glue makers and soapmakers rendered copious volumes of bones and animal fat, filling the air with a cloying smell that could be all but worn, while tanners steeped their products in vats of dog feces to make them supple. No one reached a playhouse without encountering a good deal of odor.

The new theaters did not prosper equally. Within three years of its opening, the Curtain was being used for fencing

bouts, and all other London playhouses, with the single eventual exception of the Globe, relied on other entertainments, particularly animal baiting, to fortify their earnings. The pastime was not unique to England, but it was regarded as an English specialty. Queen Elizabeth often had visitors from abroad entertained with bearbaiting at Whitehall. In its classic form, a bear was put in a ring, sometimes tethered to a stake, and set upon by mastiffs, but bears were expensive investments, so other animals (such as bulls and horses) were commonly substituted. One variation was to put a chimpanzee on the back of a horse and let the dogs go for both together. The sight of a screeching ape clinging for dear life to a bucking horse while dogs leaped at it from below was considered about as rich an amusement as public life could offer. That an audience that could be moved to tears one day by a performance of *Doctor Faustus* could return the next to the same space and be just as entertained by the frantic deaths of helpless animals may say as much about the age as any single statement could.

It was also an age that gave rise to the Puritans, a people so averse to sensual pleasure that they would rather live in a distant wilderness in the New World than embrace tolerance. Puritans detested the theater and tended to blame every natural calamity, including a rare but startling earthquake in 1580, on the playhouses. They considered theaters, with their lascivious puns and unnatural cross-dressing, a natural haunt for prostitutes and shady characters, a breeding ground of infectious diseases, a distraction from worship, and a source of unhealthy sexual excitement. All the female parts were of course played by

boys—a convention that would last until the Restoration in the 1660s. In consequence the Puritans believed that the theaters were hotbeds of sodomy—still a capital offense in Shakespeare's lifetime*—and wanton liaisons of all sorts.

There may actually have been a little something to this, as popular tales of the day suggest. In one story a young wife pleads with her husband to be allowed to attend a popular play. Reluctantly the husband consents, but with the strict proviso that she be vigilant for thieves and keep her purse buried deep within her petticoats. Upon her return home, the wife bursts into tears and confesses that the purse has been stolen. The husband is naturally astounded. Did his wife not feel a hand probing beneath her dress? Oh, yes, she responds candidly, she had felt a neighbor's hand there—"but I did not think he had come for *that*."

Fortunately for Shakespeare and for posterity, the queen brushed away all attempts to limit public amusements, including on Sundays. For one thing she liked them herself, but equally pertinent, her government enjoyed hearty revenues from licensing bowling alleys, theatrical productions, gaming houses (even though gambling was actually illegal in London), and the sale and manufacture of much that went on in them.

* Stephen Orgel makes the point that sodomy, though inveighed against in law, was tolerated in practice as long as it was discreet. Far more at risk of prosecution were incautious heterosexual females, because illicit births added inexcusably to the poor rolls.

But though plays were tolerated, they were strictly regulated. The Master of the Revels licensed all dramatic works (at a cost of 7 shillings per license) and made sure that companies performed in a manner that he considered respectful and orderly. Those who displeased him could in theory be jailed at his indefinite pleasure, and punishments were not unknown. In 1605, soon after the accession of James I, Ben Jonson and his collaborators on *Eastward Ho!* made some excellent but unwisely intemperate jokes about the sudden influx of rough and underwashed Scots to the royal court and were arrested and threatened with having their ears and noses lopped off. It was because of these dangers (and the Vagrancy Act of 1572, which specifically authorized the whipping of unlicensed vagabonds) that acting troupes attached themselves to aristocratic patrons. The patron afforded the actors some measure of protection, and they in turn carried his name across the land, lending him publicity and prestige. For a time patrons collected troupes of actors rather in the way rich people of a later age collected racehorses or yachts.

Plays were performed at about two o'clock in the afternoon. Handbills were distributed through the streets advertising what was on offer, and citizens were reminded that a play was soon to start by the appearance of a banner waving from the highest part of the structure in which a performance was to take place and a fanfare of trumpets that could be heard across much of the city. General admission for groundlings—those who stood in the open around the stage—was a penny. Those who wished to sit paid a penny more, and those who desired a cushion paid

another penny on top of that—all this at a time when a day's wage was 1 shilling (12 pence) or less a day. The money was dropped into a box, which was taken to a special room for safe-keeping—the box office.

For those who could afford an additional treat, apples and pears (both apt to be used as missiles during moments of disappointment) and nuts, gingerbread, and bottles of ale were on offer, as was the newly fashionable commodity tobacco. A small pipeful cost 3 pence—considerably more than the price of admission. There were no toilets—or at least no official ones. Despite their large capacity, theaters were reasonably intimate. No one in the audience was more than fifty feet or so from the edge of the stage.

Theaters had little scenery and no curtains (even at the Curtain), no way to distinguish day from night, fog from sunshine, battlefield from boudoir, other than through words. So scenes had to be set with a few verbal strokes and the help of a compliant audience's imagination. As Wells and Taylor note, "Oberon and Prospero have only to declare themselves invisible to become so."

No one set scenes more brilliantly and economically than Shakespeare. Consider the opening lines of *Hamlet*:

> *Barnardo*: Who's there?
> *Francisco*: Nay, answer me. Stand, and unfold yourself.
> *Barnardo*: Long live the King!
> *Francisco*: Barnardo?
> *Barnardo*: He.

In five terse lines Shakespeare establishes that it is night-time and cold ("unfold yourself" means "draw back your cloak"), that the speakers are soldiers on guard, and that there is tension in the air. With just fifteen words—eleven of them monosyllables—he has the audience's full, rapt attention.

Costumes were elaborate and much valued but not always greatly assembled with historical veracity, it would seem. We know this because a man named Henry Peacham (or so it is assumed; his name is scribbled in the margin) made a sketch of a scene in *Titus Andronicus* during one of its performances. Where and when precisely this happened is not known, but the sketch shows a critical moment in the play when Tamora begs Titus to spare her sons and portrays with some care the postures and surprisingly motley costumes (some suitably ancient, others carelessly Tudor) of the performers. For audience and players alike, it appears, a hint of antiquity was sufficient. Realism came rather in the form of gore. Sheep's or pig's organs and a little sleight of hand made possible the lifting of hearts from bodies in murder scenes, and sheep's blood was splashed about for a literal touch of color on swords and flesh wounds. Artificial limbs were sometimes strewn over imagined fields of battle—"as bloody as may be," as one set of stage directions encouraged. Plays, even the solemn ones, traditionally ended with a jig as a kind of bonus entertainment.

It was a time of rapid evolution for theatrical techniques. As Stanley Wells has written: "Plays became longer, more ambitious, more spectacular, more complex in construction, wider

in emotional range, and better designed to show off the talents of their performers." Acting styles became less bombastic. A greater naturalism emerged in the course of Shakespeare's lifetime—much of which he helped to foster. Shakespeare and his contemporaries also enjoyed a good deal of latitude in subject and setting. Italian playwrights, following the classical Roman tradition, were required to set their plays around a town square. Shakespeare could place his action wherever he wished: on or in hillsides, forts, castles, battlefields, lonesome islands, enchanted dells, anywhere an imaginative audience could be persuaded to go.

Plays, at least as written, were of strikingly variable lengths. Even going at a fair clip and without intermissions, *Hamlet* would run for nearly four and a half hours. *Richard III, Coriolanus*, and *Troilus and Cressida* were only slightly shorter. Jonson's *Bartholomew Fair* would have taken no less than five hours to perform, unless judiciously cut, as it almost certainly was. (Shakespeare and Jonson were notoriously copious. Of the twenty-nine plays of three thousand lines or more that still exist from the period 1590–1616, twenty-two are by Jonson or Shakespeare.)

A particular challenge for audience and performers alike must surely have been the practice of putting male players in female parts. When we consider how many powerful and expressive female roles Shakespeare created—Cleopatra, Lady Macbeth, Ophelia, Juliet, Desdemona—the actors must have been gifted dissemblers indeed. Rosalind in *As You Like It* has about a quarter of all the lines in the play; Shakespeare clearly

had enormous confidence in some young actor. Yet, while we often know a good deal about performers in male roles from Shakespeare's day, we know almost nothing about the conduct of the female parts. Judith Cook, in *Women in Shakespeare*, says she could not find a single record of any role of a woman played by a specific boy actor. We don't even know much about boy actors in general terms, including how old they were. For many of a conservative nature, stage transvestism was a source of real anxiety. The fear was that spectators would be attracted to both the female character and the boy beneath, thus becoming doubly corrupted.

This disdain for female actors was a Northern European tradition. In Spain, France, and Italy, women were played by women—a fact that astonished British travelers, who seem often to have been genuinely surprised to find that women could play women as competently onstage as in life. Shakespeare got maximum effect from the gender confusion by constantly having his female characters—Rosalind in *As You Like It*, Viola in *Twelfth Night*—disguise themselves as boys, creating the satisfyingly dizzying situation of a boy playing a woman playing a boy.

The golden age of theater lasted only about the length of a good human lifetime, but what a wondrously prolific and successful period it was. Between the opening of the Red Lion in 1567 and the closing of all the theaters by the Puritans seventy-five years later, London's playhouses are thought to have attracted fifty million paying customers, something like ten times the entire country's population in Shakespeare's day.

To prosper, a theater in London needed to draw as many as two thousand spectators a day—about 1 percent of the city's population—two hundred or so times a year, and to do so repeatedly against stiff competition. To keep customers coming back, it was necessary to change the plays continually. Most companies performed at least five different plays in a week, sometimes six, and used such spare time as they could muster to learn and rehearse new ones.

A new play might be performed three times in its first month, then rested for a few months or abandoned altogether. Few plays managed as many as ten performances in a year. So quite quickly there arose an urgent demand for material. What is truly remarkable is how much quality the age produced in the circumstances. Few writers made much of a living at it, however. A good play might fetch £10, but as such plays were often collaborations involving as many as half a dozen authors, an individual share was modest (and with no royalties or other further payments). Thomas Dekker cranked out, singly or in collaboration, no fewer than thirty-two plays in three years, but never pocketed more than 12 shillings a week and spent much of his career imprisoned for debt. Even Ben Jonson, who passed most of his career in triumph and esteem, died in poverty.

Plays belonged, incidentally, to the company, not the playwright. A finished play was stamped with a license from the Master of the Revels giving permission for its staging, so it needed to be retained by the company. It is sometimes considered odd that no play manuscripts or prompt books were found

among Shakespeare's personal effects at his death. In fact it would have been odd if they had been.

For authors and actors alike, the theatrical world was an insanely busy place, and for someone like William Shakespeare, who was playwright, actor, part owner, and probably de facto director as well (there were no formal directors in his day), it must have been nearly hysterical at times. Companies might have as many as thirty plays in their active repertoire, so a leading actor could be required to memorize perhaps fifteen thousand lines in a season—about the same as memorizing every word in this book—as well as remember every dance and sword thrust and costume change. Even the most successful companies were unlikely to employ more than a dozen or so actors, so a great deal of doubling up was necessary. *Julius Caesar*, for instance, has forty named characters, as well as parts for unspecified numbers of "servants," "other plebeians," and "senators, soldiers, and attendants." Although many of these had few demanding lines, or none at all, it was still necessary in every case to be fully acquainted with the relevant props, cues, positions, entrances, and exits, and to appear on time correctly attired. That in itself must have been a challenge, for nearly all clothing then involved either complicated fastenings—two dozen or more obstinate fabric clasps on a standard doublet—or yards of lacing.

In such a hothouse, reliability was paramount. Henslowe's papers show that actors were subjected to rigorous contractual obligations, with graduated penalties for missing rehearsals, being drunk or tardy, failing to be "ready apparelled" at the

right moment, or—strikingly—for wearing any stage costumes outside the playhouse. Costumes were extremely valuable, so the fine was a decidedly whopping (and thus probably never imposed) £40. But even the most minor infractions, like tardiness, could cost an actor two days' pay.

Shakespeare appears to have remained an actor throughout his professional life (unlike Ben Jonson, who quit as soon as he could afford to), for he was listed as an actor on documents in 1592, 1598, 1603, and 1608—which is to say at every phase of his career. It can't have been easy to have been an actor as well as a playwright, but it would doubtless have allowed him (assuming he wished it) much greater control than had he simply surrendered a script to others, as most playwrights did. According to tradition, Shakespeare specialized in good but fairly undemanding roles in his own plays. The Ghost in *Hamlet* is the part to which he is most often linked. In fact, we don't know what parts he played, but that they were nontaxing roles seems a reasonable assumption given the demands on him not only as writer of the plays but also in all likelihood as the person most closely involved with their staging. But it may well be that he truly enjoyed acting and craved large parts when not distracted by scripting considerations. He was listed as a principal performer in Ben Jonson's *Every Man in His Humour* in 1598 and in *Sejanus His Fall* in 1603.

It is tempting, even logical, to guess that Shakespeare when he arrived in London gravitated to Shoreditch, just north of the City walls. This was the home of the Theatre and the Curtain both, and was where many playwrights and actors lived,

drank, caroused, occasionally fought, and no less occasionally died. It was in Shoreditch, very near the Theatre, in September 1589 that the rising, and ever hotheaded, young star Christopher Marlowe, fresh from the triumphs of *Tamburlaine the Great*, fell into a heated altercation with an innkeeper named William Bradley. Swords were drawn. Marlowe's friend Thomas Watson, a playwright himself, stepped into the fray and, in inevitably confused circumstances, stabbed Bradley in the chest. The blow was fatal. Both writers spent time in prison—Marlowe very briefly, Watson for five months—but were cleared on the grounds that Bradley had provoked his own demise and that they had acted in self-defense. We may reasonably suppose that the murder of Bradley was the talk of the district that evening, but whether Shakespeare was around to hear it or not we don't know. If not yet, he soon would be, for at some point shortly after this he became, in a big and fairly sudden way, a presence in the London theater.

We are not quite sure, however, when that point was. We are not even sure when we have our first glimpse of him at work. The ever-meticulous Henslowe has a note in his diary recording a performance of "harey VI" at the Rose in the first week of March 1592. Many take this to be Shakespeare's *Henry VI, Part 1*, which would be gratifying for Shakespeare fans because "harey VI" was a great triumph. It attracted box office receipts of £3 16 shillings and 8 pence on its debut—a very considerable sum—and was performed thirteen times more in the next four months, which is to say more than almost any other play of its day. But the success of the play, particularly upon its

debut, does rather raise a question: Would people really have turned out in droves to see the premiere of a play by a little-known author or was it perhaps a play, now lost, on the same subject by someone better established? One troubling point is that Shakespeare had no recorded connection with Henslowe's company as actor or playwright.

The first certain mention of Shakespeare as playwright comes, unexpectedly enough, in an unkind note in a thin and idiosyncratic pamphlet, when he was already the author of several plays—probably five, possibly more—though there is much uncertainty about which exactly these were.

The pamphlet's full, generously descriptive title is *Greene's Groat's-Worth* of Wit, Bought with a Million of Repentance. Describing the folly of youth, the falsehood of make-shift flatterers, the misery of the negligent, and mischiefs of deceiving Courtesans. Written before his death and published at his dying request,* by Robert Greene, who did indeed fulfill the title's promise by dying while it was being prepared for publication. (Amazingly he managed in the same month to produce a second volume of deathbed thoughts called, rather irresistibly, *Greene's Vision, Written at the instant of his death.*)

Greene was a pamphleteer and poet and a leading light in a group of playwrights known to posterity as the University Wits. Mostly, however, he was a wastrel and cad. He married well but ran through his wife's money and abandoned her and their

* A groat was a small coin worth four pence.

child, and took up with a mistress of tarnished repute by whom he produced another child, grandly named Fortunatus, and with whom he lived in a tenement in Dowgate, near London Bridge. Here, after overindulging one evening on Rhenish wine and pickled herring (or so all histories report), Greene fell ill and began to die slowly and unattractively, ridden with lice and sipping whatever intoxicants his dwindling resources could muster. Somehow during this month of decline, he managed (almost certainly with a good deal of help) to produce his two collections of thoughts, based loosely on his own life and peppered with tart observations about other writers, before rasping out his last breath, on September 3, 1592. He was thirty-one or possibly thirty-two—a reasonable age for a dying Londoner.

Only two copies of *Greene's Groat's-Worth* survive, and there would not be much call for either were it not for a single arresting sentence tucked into one of its many discursive passages: "Yes, trust them not: for there is an upstart Crow, beautified with our feathers, that with his Tiger's heart wrapped in a Player's hide, supposes he is as well able to bombast out a blank verse as the best of you: and being an absolute *Johannes fac totum*, is in his own conceit the only Shake-scene in a country."

If the not-so-subtle reference to "Shake-scene" didn't identify the target at once, the reference to a "Tiger's heart wrapped in a Player's hide" almost certainly did, for it is a parody of a line in *Henry VI, Part 3*. It is clear from the context that Shakespeare had distinguished himself enough to awaken envy in a dying man but was still sufficiently fresh to be considered an upstart.

No one knows quite what Shakespeare did to antagonize the dying Greene. It may have been very personal, for all we know, but more probably it was just a case of professional jealousy. Greene evidently felt that Shakespeare's position as a player qualified him to speak lines but not to create them. Writing was clearly best left to university graduates, however dissolute. (Greene was the worst kind of snob—a university graduate from a humble background: His father was a saddler.) At any rate Shakespeare or someone speaking for him must have protested, for soon afterward Greene's editor and amanuensis, Henry Chettle, offered an apology of radiant humility and abjection, praising Shakespeare's honesty and good character, "his facetious grace in writing," and much else.

Chettle was much more grudging in apologizing to Christopher Marlowe, who was far worse maligned (though, as was usual in these tracts, not explicitly named), as Greene's slender volume accused him of atheism—a very grave charge for the time. Why Chettle was so much more respectful (or fearful) of Shakespeare than of the comparatively well-connected and always dangerous Marlowe is an interesting but unresolvable puzzle. At all events no one would ever attack Shakespeare in such a way again.

Just at the moment that Shakespeare enters the theatrical record, the record itself is suspended owing to a particularly severe outbreak of plague. Four days after the death of Robert Greene, London's theaters were officially ordered shut, and they would

remain so for just under two years, with only the briefest remissions. It was a period of great suffering. In London at least ten thousand people died in a single year. For theatrical companies it meant banishment from the capital and a dispiritingly itinerant existence on tour.

What Shakespeare did with himself at this time is not known. Ever elusive, he now disappears from recorded sight for two years more. As always there are many theories as to where he passed the plague years of 1592 and 1593. One is that he spent the time traveling in Italy, which would account for a rush of Italian plays upon his return—*The Taming of the Shrew, The Two Gentlemen of Verona, The Merchant of Venice, Romeo and Juliet*—though at least one of these was probably written already and none requires a trip to Italy to explain its existence. All that is certain is that in April 1593, just before his twenty-ninth birthday and little more than half a year after the theaters had shut, William Shakespeare produced a narrative poem called *Venus and Adonis* with a dedication so florid and unctuous that it can raise a sympathetic cringe even after four hundred years. The dedication says:

> Right Honourable, I know not how I shall offend in dedicating my unpolished lines to your lordship, nor how the world will censure me for choosing so strong a prop to support so weak a burden. Only, if your honour seem but pleased, I account myself highly praised, and vow to take advantage of all idle hours till I have honoured you with some graver labour. But if the first heir

of my invention prove deformed, I shall be sorry it had
so noble a godfather. . . .

The person at whom this gush was directed was not an aged
worthy, but a wan, slender, exceedingly effeminate youth of
nineteen, Henry Wriothesley (pronounced "rizzly"), third Earl
of Southampton and Baron of Titchfield. Southampton grew up
at the heart of the court. His father died when he was just seven,
and he was placed under the wardship of Lord Burghley, the
queen's lord treasurer—effectively her prime minister. Burghley
saw to his education and, when Southampton was just seventeen,
sought to have him marry his granddaughter, Lady Elizabeth de
Vere, who was in turn daughter of Edward de Vere, the seven-
teenth Earl of Oxford and longtime favorite among those who
think Shakespeare was not Shakespeare. Southampton declined
to proceed with the marriage, for which he had to pay a colossal
forfeit of £5,000 (something like £2.5 million in today's money).
He really didn't want to marry Burghley's granddaughter.

Southampton, it appears, enjoyed the intimate company of
men and women both. He had a mistress at court, one Eliz-
abeth Vernon, but equally while serving in Ireland as Lord-
General of Horse under his close friend the Earl of Essex, he
shared quarters with a fellow officer whom he would "hug in
his arms and play wantonly with," in the words of one scan-
dalized observer. He must have made an interesting soldier,
for his most striking quality was his exceeding effeminacy.
We know precisely how he looked—or at least wished to be
remembered—because Nicholas Hilliard, the celebrated por-

traitist, produced a miniature of him showing him with flowing auburn locks draped over his left shoulder, at a time when men did not normally wear their hair so long or arrange it with such smoldering allure.

Matters took a further interesting lurch in the spring of 2002 when another portrait of Southampton was identified at a stately home, Hatchlands Park in Surrey, showing him dressed as a woman (or an exceedingly camp man), a pose strikingly reminiscent of the beautiful youth with "a woman's face, with Nature's own hand painted" described with such tender admiration in Sonnet 20. The date attributed to the painting, 1590–1593, was just the time that Shakespeare was beseeching Southampton's patronage.

We've no idea how much or how little Southampton admired the poem dedicated to him, but the wider world loved it. It was the greatest publishing success of Shakespeare's career— far more successful in print than any of his plays—and was reprinted at least ten times in his lifetime (though only one first-edition copy survives, in the Bodleian Library in Oxford). Written in narrative form and sprawling over 1,194 lines, *Venus and Adonis* was rich and decidedly racy for its day, though actually quite tame compared with the work on which it was based, Ovid's *Metamorphoses*, which contains eighteen rapes and a great deal of pillage, among much else. Shakespeare threw out most of the violence but played on themes—love, lust, death, the transient frailty of beauty—that spoke to Elizabethan tastes and ensured the poem's popularity.

Some of it is a little rich for modern tastes—for instance:

And now she beats her heart, whereat it groans. . .
"Ay me!" she cries, and twenty times, "Woe, woe!"

But such lines struck a chord with Elizabethan readers and made the work an instant hit. The publisher was Richard Field, with whom Shakespeare had grown up in Stratford, but it did so well that a more successful publisher, John Harrison, bought out Field's interest. The following year Harrison published a follow-up poem by Shakespeare, *The Rape of Lucrece*, based on Ovid's *Fasti*. This poem, considerably longer at 1,855 lines and written in a seven-line stanza form known as rhyme royal, was primarily a paean to chastity and, like chastity itself, was not so popular.

Again there was an elaborate dedication to the foppish earl:

To the Right Honourable Henry Wriothesely, Earl of Southampton and Baron of Titchfield.

The love I dedicate to your Lordship is without end; whereof this pamphlet, without beginning, is but a superfluous moiety. The warrant I have of your honourable disposition, not the worth of my untutored lines, makes it assured of acceptance. What I have done is yours; what I have to do is yours; being part in all I have, devoted yours. Were my worth greater, my duty would sow greater; meantime, as it is, it is bound to your Lordship, to whom I wish long life still lengthened with all happiness.

Your Lordship's in all duty,
William Shakespeare

As these dedications are the only two occasions when Shakespeare speaks directly to the world in his own voice, scholars have naturally picked over them to see what might reasonably be deduced from them. What many believe is that the second dedication shows a greater confidence and familiarity—and possibly affection—than the first. A. L. Rowse, for one, could think of "no Elizabethan dedication that gives one more the sense of intimacy" and that conclusion is echoed with more or less equal vigor in many other assessments.

In fact we know nothing at all about the relationship, if any, that existed between Shakespeare and Southampton. But as Wells and Taylor put it in their edition of the complete works, "the affection with which Shakespeare speaks of him in the dedication to *Lucrece* suggests a strong personal connection." The suspicion is that Southampton was the beautiful youth with whom Shakespeare may have had a relationship, as described in the sonnets—which may have been written about the same time, though the sonnets would not be published for fifteen years. But according to Martin Wiggins of the University of Birmingham, addressing work to a nobleman "was commonly only a speculative bid for patronage." And Shakespeare was just one of several poets—Thomas Nashe, Gervase Markham, John Clapham, and Barnabe Barnes were others—vying for Southampton's benediction during the same period (his rivals' obsequious dedications, not incidentally, make

Shakespeare's entreaties look restrained, honest, and frankly dignified).

Southampton was not, in any case, in a position to bestow largesse in volume. Although he enjoyed an income of £3,000 a year (something like £1.5 million in today's money) upon reaching his majority, he also inherited vast expenses and was dissolute into the bargain. Moreover, under the terms of his inheritance, he had to pass a third of any earnings to his mother. Within a few years he was, to quote Wiggins again, "virtually bankrupt." All of which makes it unlikely that Southampton gave—or was ever in a position to give—Shakespeare £1,000, a story first related by Shakespeare's biographer Nicholas Rowe in the early 1700s and endorsed surprisingly often ever since: for instance, by the Shakespeare scholar Sidney Lee in the *Dictionary of National Biography*.

So by 1594 William Shakespeare was clearly on the way to success. He was the author of two exceedingly accomplished poems and he had the patronage of a leading aristocrat. But rather than capitalize on this promising beginning, he left the field of poetry and returned all but exclusively to the theater, a move that must have seemed at least mildly eccentric, if not actively willful, for playwriting was not an esteemed profession, and its practice, however accomplished, gained one little critical respect.

Yet this was precisely the world that Shakespeare now wholeheartedly embraced. He never dedicated anything else to Southampton or any other aristocrat, or sought anyone's pa-

tronage again. He wrote for publication only once more that we know of—with the poem *The Phoenix and the Turtle*, published in 1601. Nothing else bearing his name was published with his obvious consent in his lifetime, including the plays that he now turned to almost exclusively.

The theatrical scene that Shakespeare found was much altered from two years before. For one thing, it was without his greatest competitor, Christopher Marlowe, who had died the previous year. Marlowe was just two months older than Shakespeare. Though from a modest background himself—he was the son of a shoemaker from Canterbury—he had gone to Cambridge (on a scholarship), and so enjoyed an elevated status.

Goodness knows what he might have achieved, but in 1593 he fell into trouble in a very big way. In the spring of that year inflammatory anti-immigrant notices began to appear all over London bearing lines of verse inspired by popular dramas, including in one instance a vicious parody of Marlowe's *Tamburlaine*. The government by this time was so obsessed with internal security that it spent £12,000 a year—a fabulous sum—spying on its own citizens. This was an era when one really didn't wish to attract the critical attention of the authorities. Among those interrogated was Thomas Kyd, Marlowe's friend and former roommate and author of the immensely popular *Spanish Tragedy*. Under torture (or possibly just the threat of it) at Bridewell Prison, Kyd accused Marlowe of being "irreligious, intemperate, and of cruel heart," but above all of being a blasphemer and atheist. These were serious charges indeed.

Marlowe was brought before the Privy Council, questioned, and released on a bond that required him to stay within twelve miles of the royal court wherever it happened to be so that his case could be dealt with quickly when it pleased his accusers to turn to it. He faced, at the very least, having his ears cut off—that was if things went well—so it must have been a deeply uneasy time for him. As Marlowe's biographer David Riggs has written, "There were no acquittals in Tudor state courts."

It was against this background that Marlowe went drinking with three men of doubtful character at the house of a widow, Eleanor Bull, in Deptford in East London. There, according to a subsequent coroner's report, a dispute arose over the bill, and Marlowe—who truly was never far from violence—seized a dagger and tried to stab one Ingram Frizer with it. Frizer, in self-defense, turned the weapon back on Marlowe and stabbed him in the forehead above the right eye—a difficult place to strike a killing blow, one would have thought, but killing him outright. That is the official version, anyway. Some historians believe Marlowe was assassinated at the behest of the crown or its senior agents. Whatever the motivation, he was dead at twenty-nine.

At that age Shakespeare was writing comparative trifles—*Love's Labour's Lost*, *The Two Gentlemen of Verona*, and *The Comedy of Errors* are all probably among his works of this period. Marlowe by contrast had written ambitious and appreciable dramas: *The Jew of Malta*, *The Tragical History of Doctor Faustus*, and *Tamburlaine the Great*. "If Shakespeare too had

died in that year," Stanley Wells has written, "we should now regard Marlowe as the greater writer."

No doubt. But what if both had lived? Could either have sustained the competition? Shakespeare, it seems fair to say, had more promise for the long term. Marlowe possessed little gift for comedy and none at all, that we can see, for creating strong female roles—areas where Shakespeare shone. Above all it is impossible to imagine a person as quick to violence and as erratic in temperament as Christopher Marlowe reaching a wise and productive middle age. Shakespeare had a disposition built for the long haul.

Kyd died the next year, aged just thirty-six, never having recovered from his ordeal at Bridewell. Greene was dead already, of course, and Watson followed him soon after. Shakespeare would have no serious rivals until the emergence of Ben Jonson in 1598.

For theatrical troupes the plague years were an equally terminal moment. The endless trudge in search of provincial engagements proved too much for many companies, and one by one they disbanded—Hertford's, Sussex's, Derby's, and Pembroke's all fading away more or less at once. By 1594 only two troupes of note remained: the Admiral's Men under Edward Alleyn, and a new group, the Lord Chamberlain's Men (named for the head of the queen's household), led by Richard Burbage and comprising several talents absorbed from recently extinguished companies. Among these talents were John Heminges, who would become Shakespeare's close friend and (some thirty

years in the future) coeditor of the First Folio, and the celebrated comic Will Kemp, for whom Shakespeare would (it is reasonably presumed) write many of his most famous comedic roles, such as Dogberry in *Much Ado About Nothing*.

Shakespeare would spend the rest of his working life with this company. As Wells and Taylor note, "He is the only prominent playwright of his time to have had so stable a relationship with a single company." It was clearly a happy and well-run outfit, and its members were commendably—or at the very least comparatively—sober, diligent, and clean living.

Shakespeare seems to have been unusual among the troupe in not being a conspicuously devoted family man. Burbage was a loving husband and father of seven in Shoreditch. Heminges and Condell were likewise steady fellows, living as neighbors in the prosperous parish of Saint Mary Aldermanbury, where they were pillars of their church and prodigious procreators, producing no fewer than twenty-three children between them.

In short they led innocuous lives. They did not draw daggers or brawl in pubs. They behaved like businessmen. And six times a week they gathered together, dressed up in costumes and makeup, and gave the world some of the most sublime and unimprovable hours of pleasure it has ever known.

Chapter Five

The Plays

NEARLY EVERYONE AGREES THAT William Shake-
speare's career as a playwright began in about 1590, but
there is much less agreement on which plays began it. Depend-
ing on whose authority you favor, Shakespeare's debut written
offering might be any of at least eight works: *The Comedy of
Errors*, *The Two Gentleman of Verona*, *The Taming of the Shrew*,
Titus Andronicus, *King John*, or the three parts of *Henry VI*.

The American authority Sylvan Barnet lists *The Comedy
of Errors* as Shakespeare's first play with *Love's Labour's Lost*
second, but more recently Stanley Wells and Gary Taylor, in
the *Oxford Complete Works*, credit him with ten other plays—
more than a quarter of his output—before either of those two
comes along. Wells and Taylor place *The Two Gentlemen of
Verona* at the head of their list—not on any documentary evi-
dence, as they freely concede, but simply because it is notably
unpolished (or has "an uncertainty of technique suggestive of

inexperience," as they rather more elegantly put it). The Arden Shakespeare, meanwhile, puts *The Taming of the Shrew* first, while the Riverside Shakespeare places the first part of *Henry VI* first. Hardly any two lists are the same.

For many plays all we can confidently adduce is a *terminus ad quem*—a date beyond which they could not have been written. Sometimes evidence of timing is seen in allusions to external events, as in *A Midsummer Night's Dream*, in which seemingly pointed references are made to unseasonable weather and bad harvests (and England had very bad harvests in 1594 and 1595), or in *Romeo and Juliet* when Nurse speaks of an earthquake of eleven years before (London had a brief but startling one in 1580), but such hints are rare and often doubtful anyway. Many other judgments are made on little more than style. Thus *The Comedy of Errors* and *Titus Andronicus* "convey an aroma of youth," in the words of Samuel Schoenbaum, while Barnet can, without blushing, suggest that *Romeo and Juliet* came before *Othello* simply because "one feels Othello is later."

Arguments would run far deeper were it not for the existence of a small, plump book by one Francis Meres called *Palladis Tamia: Wit's Treasury*. Published in 1598, it is a 700-page compendium of platitudes and philosophical musings, little of it original and even less of it of interest to history except for one immeasurably helpful passage first noticed by scholars some two hundred years after Shakespeare's death: "As Plautus and Seneca are accounted the best for comedy and tragedy among the Latins, so Shakespeare among the English is the most excellent in both kinds for the stage. For comedy, wit-

ness his *Gentlemen of Verona*, his *Errors*, his *Love Labour's Lost*, his *Love Labour's Won*, his *Midsummer Night's Dream*, and his *Merchant of Venice*; for tragedy, his *Richard the Second*, *Richard the Third*, *Henry the Fourth*, *King John*, *Titus Andronicus*, and his *Romeo and Juliet*."

This was rich stuff indeed. It provided the first published mention of four of Shakespeare's plays—*The Merchant of Venice*, *King John*, *The Two Gentlemen of Verona*, and *A Midsummer Night's Dream*—and additionally, in a separate passage, established that he had written at least some sonnets by this time, though they wouldn't be published as a collected work for a further eleven years.

Rather more puzzling is the mention of *Love's Labour's Won*, about which nothing else is known. For a long time it was assumed that this was an alternative name for some play that we already possess—in all likelihood *The Taming of the Shrew*, which is notably absent from Meres's list. Shakespeare's plays were occasionally known by other names: *Twelfth Night* was sometimes called *Malvolio,* and *Much Ado About Nothing* was sometimes *Benedick and Beatrice*, so the possibility of a second title was plausible.

In 1953 the mystery deepened when an antiquarian book dealer in London, while moving stock, chanced upon a fragment of a bookseller's inventory from 1603, which listed *Love's Labour's Won* and *The Taming of the Shrew* together—clearly suggesting that they weren't the same play after all, and giving further evidence that *Love's Labour Won* really was a separate play. If, as the inventory equally suggests, it existed in pub-

lished form, there may once have been as many as 1,500 copies in circulation, so there is every chance that the play may one day turn up somewhere (a prospect thought most unlikely for Shakespeare's other lost play, *Cardenio*, which appears to have existed only in manuscript). It is all a little puzzling. If *Love's Labour's Won* is a real and separate play, and was published, a natural question is why Heminges and Condell didn't include it in the First Folio. No one can say.

In whatever order the plays came, thanks to Meres we know that by 1598, when he had been at it for probably much less than a decade, Shakespeare had already proved himself a dab hand at comedy, history, and tragedy, and had done enough—much more than enough, in fact—to achieve a lasting reputation. His success was not, it must be said, without its shortcuts. Shakespeare didn't scruple to steal plots, dialogue, names, and titles—whatever suited his purpose. To paraphrase George Bernard Shaw, Shakespeare was a wonderful teller of stories so long as someone else had told them first.

But then this was a charge that could be laid against nearly all writers of the day. To Elizabethan playwrights plots and characters were common property. Marlowe took his *Doctor Faustus* from a German *Historia von D. Johann Fausten* (by way of an English translation) and *Dido Queen of Carthage* directly from the Virgil's *Aeneid*. Shakespeare's *Hamlet* was preceded by an earlier Hamlet play, unfortunately now lost and its author unknown (though some believe it was the hazy genius Thomas Kyd), leaving us to guess how much his version owed to the original. His *King Lear* was similarly inspired by an earlier *King*

Leir. His *Most Excellent and Lamentable Tragedy of Romeo and Juliet* (to give it its formal original title) was freely based on the poem *The Tragicall History of Romeus and Juliet* by a promising young talent named Arthur Brooke, who wrote it in 1562 and then unfortunately drowned. Brooke in turn had taken the story from an Italian named Matteo Bandello. *As You Like It* was borrowed quite transparently from a work called *Rosalynde*, by Thomas Lodge, and *The Winter's Tale* is likewise a reworking of *Pandosto*, a forgotten novel by Shakespeare's bitter critic Robert Greene. Only a few of Shakespeare's works—in particular the comedies *A Midsummer Night's Dream, Love's Labour's Lost,* and *The Tempest*—appear to have borrowed from no one.

What Shakespeare did, of course, was take pedestrian pieces of work and endow them with distinction and, very often, greatness. Before he reworked it *Othello* was insipid melodrama. In *Lear's* earlier manifestation, the king was not mad and the story had a happy ending. *Twelfth Night* and *Much Ado About Nothing* were inconsequential tales in a collection of popular Italian fiction. Shakespeare's particular genius was to take an engaging notion and make it better yet. In *The Comedy of Errors*, he borrows a simple but effective plot device from Plautus—having twin brothers who have never met appear in the same town at the same time—but increases the comic potential exponentially by giving the brothers twin servants who are similarly underinformed.

Slightly more jarring to modern sensibilities was Shakespeare's habit of lifting passages of text almost verbatim from other sources and dropping them into his plays. *Julius Caesar*

and *Antony and Cleopatra* both contain considerable passages taken with only scant alteration from Sir Thomas North's magisterial translation of Plutarch, and *The Tempest* pays a similar uncredited tribute to a popular translation of Ovid. Marlowe's "Whoever loved that loved not at first sight?" from *Hero and Leander* reappears unchanged in Shakespeare's *As You Like It*, and a couplet from Marlowe's *Tamburlaine*—

> *Hola, ye pampered jades of Asia*
> *What, can ye draw but twenty miles a day?*

—finds its way into Henry IV, Part 2 as

> *And hollow pampered jades of Asia*
> *Which cannot go but thirty miles a day.*

Shakespeare at his worst borrowed "almost mechanically," in the words of Stanley Wells, who cites a passage in *Henry V* in which the youthful king (and, more important, the audience) is given a refresher course in French history that is taken more or less verbatim from Raphael Holinshed's *Chronicles*. *Coriolanus*, in the First Folio, contains two lines that make no sense until one goes back to Sir Thomas North's *Lives of the Noble Grecians and Romans* and finds the same lines *and* the line immediately preceding, which Shakespeare (or more probably a subsequent scribe or compositor) inadvertently left out. Again, however, such borrowing had ample precedent. Marlowe in his turn took several lines from Spenser's *The Faerie Queene* and

dropped them almost unchanged into *Tamburlaine. The Faerie Queene*, meanwhile, contains passages lifted whole (albeit in translation) from a work by the Italian poet Ludovico Ariosto.

In the rush to entertain masses of people repeatedly, the rules of presentation became exceedingly elastic. In classical drama plays were strictly either comedies or tragedies. Elizabethan playwrights refused to be bound by such rigidities and put comic scenes in the darkest tragedies—the porter answering a late knock in *Macbeth*, for instance. In so doing they invented comic relief. In classical drama only three performers were permitted to speak in a given scene, and no character was allowed to talk to himself or the audience—so there were no soliloquies and no asides. These are features without which Shakespeare could never have become Shakespeare. Above all, plays before Shakespeare's day were traditionally governed by what were known as "the unities"—the three principles of dramatic presentation derived from Aristotle's *Poetics*, which demanded that dramas should take place in one day, in one place, and have a single plot. Shakespeare was happy enough to observe this restriction when it suited him (as in *The Comedy of Errors*), but he could never have written *Hamlet* or *Macbeth* or any of his other greatest works if he had felt strictly bound by it.

Other theatrical conventions were unformed or just emerging. The division of plays into acts and scenes—something else strictly regulated in classical drama—was yet unsettled in England. Ben Jonson inserted a new scene and scene number each time an additional character stepped onstage, however briefly or inconsequentially, but others did not use scene divisions at

all. For the audience it mattered little, since action was continuous. The practice of pausing between acts didn't begin until plays moved indoors, late in Shakespeare's career, and it became necessary to break from time to time to trim the lights.

Almost the only "rule" in London theater that was still faithfully followed was the one we now call, for convenience, the law of reentry, which stated that a character couldn't exit from one scene and reappear immediately in the next. He had rather to go away for a while. Thus, in *Richard II*, John of Gaunt makes an abrupt and awkward departure purely to be able to take part in a vital scene that follows. Why this rule out of all the many was faithfully observed has never, as far as I can make out, been satisfactorily explained.

But even by the very relaxed standards of the day, Shakespeare was invigoratingly wayward. He could, as in *Julius Caesar*, kill off the title character with the play not half done (though Caesar does come back later, briefly, as a ghost). He could write a play like *Hamlet*, where the main character speaks 1,495 lines (nearly as many as the number spoken by *all* the characters combined in *The Comedy of Errors*) but disappears for unnervingly long stretches—for nearly half an hour at one point. He constantly teased reality, reminding the audience that they were not in the real world but in a theater, as when he asked in *Henry V*, "Can this cockpit hold the vastie fields of France?" or implored the audience in *Henry VI, Part 3* to "eke out our performance with your mind."

His plays were marvelously variable, with the number of scenes ranging from seven to forty-seven, and with the number

of speaking parts ranging from fourteen to more than fifty. The average play of the day ran to about 2,700 lines, giving a performance time of two and a half hours. Shakespeare's plays ranged from fewer than 1,800 lines (for *Comedy of Errors*) to more than 4,000 (for *Hamlet*, which could take nearly five hours to play, though possibly no audience of his day ever saw it in full). On average his plays were made up of about 70 percent blank verse, 5 percent rhymed verse, and 25 percent prose, but he changed the proportions happily to suit his purpose. His history plays aside, he set two plays, *The Merry Wives of Windsor* and *King Lear*, firmly in England; he set none at all in London; and he never used a plot from his own times.

Shakespeare was not a particularly prolific writer. Thomas Heywood wrote or cowrote more than two hundred plays, five times the number Shakespeare produced in a career of similar length. Even so, signs of haste abound in Shakespeare's work, even in the greatest of his plays. *Hamlet* is a student at the beginning of the play and thirty years old by its end, even though nothing like enough time has passed in the story. The Duke in *The Two Gentlemen of Verona* puts himself in Verona when in fact he can only mean Milan. *Measure for Measure* is set in Vienna, and yet the characters nearly all have Italian names.

Shakespeare may be the English language's presiding genius, but that isn't to say he was without flaws. A certain messy exuberance marked much of what he did. Sometimes it is just not possible to know quite what he meant. Jonathan Bate, writing in *The Genius of Shakespeare*, notes that a glancing six-word compliment to the queen in *A Midsummer Night's Dream* ("fair

vestal enthroned by the west") is so productive of possible inter-
pretation that it spawned twenty pages of discussion in a vario-
rum edition* of Shakespeare's works. Nearly every play has at
least one or two lines that defeat interpretation, like these from
Love's Labour's Lost:

> *O paradox! black is the badge of hell,*
> *The hue of dungeons and the school of night.*

What exactly he meant by "the school of night" is really
anyone's guess. Similarly uncertain is a reference early in *The
Merchant of Venice* to "my wealthy Andrew docked in sand,"
which could refer to a ship but possibly to a person. The most
ambiguous example of all, however, is surely the line in *King
Lear* that appeared originally (in the Quarto edition of 1608)
as "swithald footed thrice the old, a nellthu night more and
her nine fold." Though the sentence has appeared in many ver-
sions in the four centuries since, no one has ever got it close to
making convincing sense.

"Shakespeare was capable of prolixity, unnecessary ob-
scurity, awkwardness of expression, pedestrian versifying and
verbal inelegance," writes Stanley Wells. "Even in his greatest
plays we sometimes sense him struggling with plot at the ex-
pense of language, or allowing his pen to run away with him

* An edition that includes the complete works and notes from various
commentators.

in speeches of greater length than the situation warrants." Or as Charles Lamb put it much earlier, Shakespeare "runs line into line, embarrasses sentences and metaphors; before one idea has burst its shell, another is hatched out and clamorous for disclosure."

Shakespeare was celebrated among his contemporaries for the speed with which he wrote and the cleanness of his copy, or so his colleagues John Heminges and Henry Condell would have us believe. "His mind and hand went together," they wrote in the introduction to the First Folio, "and what he thought he uttered with that easiness that we have scarce received from him a blot in his papers." To which Ben Jonson famously replied in exasperation: "Would he had blotted a thousand!"

In fact he may have. The one place where we might *just* see Shakespeare at work is in the manuscript version of a play of the life of Sir Thomas More. The play was much worked on, and is in six hands (one of the authors was Henry Chettle, the man who apologized abjectly to Shakespeare for his part in the publishing of Greene's *Groat's-Worth*). It was never performed. Since its subject was a loyal, passionate Catholic who defied a Tudor monarch, it is perhaps a little surprising that it occurred as a suitable subject to anyone at all.

Some authorities believe that Shakespeare wrote three of the surviving pages. If so, they give an interesting insight, since they employ almost no punctuation and are remarkably—breathtakingly—liberal in their spelling. The word *sheriff*, as Stanley Wells notes, is spelled five ways in five lines—as *shreiff*, *shreef*, *shreeve*, *Shreiue*, and *Shreue*—which must be something

of a record even by the relaxed and imaginative standards of Elizabethan orthography. The text also has lines crossed out and interlineations added, showing that Shakespeare did indeed blot—if indeed it was he. The evidence for Shakespeare is based on similarities in the letter *a* in Shakespeare's signature and the More manuscript, the high number of *y* spellings (writing *tyger* rather than *tiger*, for instance, a practice thought to be old-fashioned and provincial), and the fact that a very odd spelling, *scilens* (for *silence*), appears in the manuscript for *Thomas More* and in the quarto version of *Henry IV, Part 2*. This assumes, of course, that the printer used Shakespeare's manuscript and faithfully observed its spellings, neither of which is by any means certain or even compellingly probable. Beyond that, there is really nothing to go on but a gut feeling—a sense that the passage is recognizably the voice of Shakespeare.

It is certainly worth noting that the *idea* that Shakespeare might have had a hand in the play dates only from 1871. It is also worth noting that Sir Edward Maunde Thompson, the man who declared the passages to be by Shakespeare, was a retired administrator at the British Museum, not an active paleographer, and was in any case not formally trained in that inexact science. At all events nothing from Shakespeare's own age links him to the enterprise.

Much is often made of Shakespeare's learning—that he knew as much as any lawyer, doctor, statesman, or other accomplished professional of his age. It has even been suggested—seriously, it would appear—that two lines in *Hamlet* ("Doubt that the stars are fire / Doubt that the sun doth move")

indicate that he deduced the orbital motions of heavenly bodies well before any astronomer did. With enough exuberance and selective interpretation it is possible to make Shakespeare seem a veritable committee of talents. In fact a more sober assessment shows that he was pretty human.

He had some command of French, it would seem, and evidently quite a lot of Italian (or someone who could help him with quite a lot of Italian), for *Othello* and *The Merchant of Venice* closely followed Italian works that did not exist in English translation at the time he wrote. His vocabulary showed a more than usual interest in medicine, law, military affairs, and natural history (he mentions 180 plants and employs 200 legal terms, both large numbers), but in other respects Shakespeare's knowledge was not all that distinguished. He was routinely guilty of anatopisms—that is, getting one's geography wrong—particularly with regard to Italy, where so many of his plays were set. So in *The Taming of the Shrew*, he puts a sailmaker in Bergamo, approximately the most landlocked city in the whole of Italy, and in *The Tempest* and *The Two Gentlemen of Verona* he has Prospero and Valentine set sail from, respectively, Milan and Verona even though both cities were a good two days' travel from salt water. If he knew Venice had canals, he gave no hint of it in either of the plays he set there. Whatever his other virtues, Shakespeare was not conspicuously worldly.

Anachronisms likewise abound in his plays. He has ancient Egyptians playing billiards and introduces the clock to Caesar's Rome 1,400 years before the first mechanical tick was heard there. Whether by design or from ignorance, he could

be breathtakingly casual with facts when it suited his purposes to be so. In *Henry VI, Part 1*, for example, he dispatches Lord Talbot twenty-two years early, conveniently allowing him to predecease Joan of Arc. In *Coriolanus* he has Lartius refer to Cato three hundred years before Cato was born.

Shakespeare's genius had to do not really with facts, but with ambition, intrigue, love, suffering—things that aren't taught in school. He had a kind of assimilative intelligence, which allowed him to pull together lots of disparate fragments of knowledge, but there is almost nothing that speaks of hard intellectual application in his plays—unlike, say, those of Ben Jonson, where learning hangs like bunting on every word. Nothing we find in Shakespeare betrays any acquaintance with Tacitus, Pliny, Suetonius, or others who influenced Jonson and were second nature to Francis Bacon. That is a good thing—a very good thing indeed—for he would almost certainly have been less Shakespeare and more a showoff had he been better read. As John Dryden put it in 1668: "Those who accuse him to have wanted learning, give him the greater commendation: he was naturally learn'd."

Much has been written about the size of Shakespeare's vocabulary. It is actually impossible to say how many words Shakespeare knew, and in any case attempting to do so would be a fairly meaningless undertaking. Marvin Spevack in his magnificent and hefty concordance—the most scrupulous, not to say obsessive, assessment of Shakespearean idiom ever undertaken—counts 29,066 different words in Shakespeare, but that rather generously includes inflected forms and contrac-

tions. If instead you treat all the variant forms of a word—for example, *take, takes, taketh, taking, tak'n, taken, tak'st, tak't, took, tooke, took'st,* and *tookst*—as a single word (or "lexeme," to use the scholarly term), which is the normal practice, his vocabulary falls back to about 20,000 words, not a terribly impressive number. The average person today, it is thought, knows probably 50,000 words. That isn't because people today are more articulate or imaginatively expressive but simply because we have at our disposal thousands of common words—*television, sandwich, seatbelt, chardonnay, cinematographer*—that Shakespeare couldn't know because they didn't yet exist.

Anyway, and obviously, it wasn't so much a matter of how many words he used, but what he did with them—and no one has ever done more. It is often said that what sets Shakespeare apart is his ability to illuminate the workings of the soul and so on, and he does that superbly, goodness knows, but what really characterizes his work—every bit of it, in poems and plays and even dedications, throughout every portion of his career—is a positive and palpable appreciation of the transfixing power of language. *A Midsummer Night's Dream* remains an enchanting work after four hundred years, but few would argue that it cuts to the very heart of human behavior. What it does do is take, and give, a positive satisfaction in the joyous possibilities of verbal expression.

And there was never a better time to delve for pleasure in language than the sixteenth century, when novelty blew through English like a spring breeze. Some twelve thousand words, a phenomenal number, entered the language between 1500 and 1650, about half of them still in use today, and old words

were employed in ways that had not been tried before. Nouns became verbs and adverbs; adverbs became adjectives. Expressions that could not grammatically have existed before—such as "breathing one's last" and "backing a horse," both coined by Shakespeare—were suddenly popping up everywhere. Double negatives and double superlatives—"the most unkindest cut of all"—troubled no one and allowed an additional degree of emphasis that has since been lost.

Spelling was luxuriantly variable, too. You could write "St Paul's" or "St Powles" and no one seemed to notice or care. Gracechurch Street was sometimes "Gracious Steet," sometimes "Grass Street"; Stratford-upon-Avon became at times "Stratford upon *Haven*." People could be extraordinarily casual even with their own names. Christopher Marlowe signed himself "Cristofer Marley" in his one surviving autograph and was registered at Cambridge as "Christopher Marlen." Elsewhere he is recorded as "Morley" and "Merlin," among others. In like manner the impresario Philip Henslowe indifferently wrote "Henslowe" or "Hensley" when signing his name, and others made it Hinshley, Hinchlow, Hensclow, Hynchlowes, Inclow, Hinchloe, and a half dozen more. More than eighty spellings of Shakespeare's name have been recorded, from "Shappere" to "Shaxberd." (It is perhaps worth noting that the spelling we all use is not the one endorsed by the *Oxford English Dictionary*, which prefers "Shakspere.") Perhaps nothing speaks more eloquently of the variability of spelling in the age than the fact that a dictionary published in 1604, *A Table Alphabeticall of Hard Words*, spelled "words" two ways on the title page.

Pronunciations, too, were often very different from today's. We know from Shakespeare that *knees, grease, grass,* and *grace* all rhymed (at least more or less), and that he could pun *reason* with *raisin* and *Rome* with *room.* The first hundred or so lines of *Venus and Adonis* offer such striking rhyme pairs as *satiety* and *variety, fast* and *haste, bone* and *gone, entreats* and *frets, swears* and *tears, heat* and *get.* Elsewhere *plague* is rhymed with *wage, grapes* with *mishaps, Calais* with *challice.* (The name of the French town was often spelled "Callis" or "Callice.")

Whether or not it was necessary to pronounce all the letters in a word—such as the *k*'s in *knight* and *knee*—was a hot issue. Shakespeare touches upon it comically in *Love's Labour's Lost* when he has the tedious Holofernes attack those "rackers of or-thography . . . who would call calf 'cauf,' half 'hauf,' neighbour 'nebour' and neigh 'ne.'"

Much of the language Shakespeare used is lost to us now without external guidance. In an experiment in 2005, the Globe in London staged a production of *Troilus and Cressida* in "Early Modern English" or "Original Pronunciation." The critic John Lahr, writing in the *New Yorker*, estimated that he could understand only about 30 percent of what was said. Even with modern pronunciations, meanings will often be missed. Few modern listeners would realize that in *Henry V* when the French princess Catherine mispronounces the English "neck" as "nick," she has perpetrated a gross (and to a Shakespearean audience hugely comical) obscenity—though Shakespeare's language on the whole was actually quite clean, indeed almost prudish. Where Ben Jonson manured his plays, as it were, with

frequent interjections of "turd i' your teeth," "shit o' your head," and "I fart at thee," Shakespeare's audiences had to be content with a very occasional "a pox on't," "God's bread," and one "whoreson jackanapes." (After 1606 profanities were subject to hefty fines and so largely vanished.)

In many ways the language Shakespeare used was quite modern. He never employed the old-fashioned *seeth* but rather used the racier, more modern *sees*, and much preferred *spoke* to *spake*, *cleft* to *clave*, and *goes* to *goeth*. The new King James Bible, by contrast, opted for the older forms in each instance. At the same time Shakespeare maintained a lifelong attachment to *thou* in preference to *you* even though by the end of the sixteenth century *thou* was quaint and dated. Ben Jonson used it hardly at all. He was also greatly attached to, and remarkably unself-conscious about, provincialisms, many of which became established in English thanks to his influence (among them *cranny*, *forefathers*, and *aggravate*), but initially grated on the ears of sophisticates.

He coined—or, to be more carefully precise, made the first recorded use of—2,035 words, and interestingly he indulged the practice from the very outset of his career. *Titus Andronicus* and *Love's Labour's Lost*, two of his earliest works, have 140 new words between them.

Not everyone appreciated this creative impulse. When Robert Greene referred to him as being "beautified by our feathers," he was mocking a Shakespeare neologism in *beautified*. Undaunted, Shakespeare accelerated the pace as his career proceeded. In plays written during his most productive and in-

ventive period—*Macbeth*, *Hamlet*, *Lear*—neologisms occur at the fairly astonishing rate of one every two and a half lines. *Hamlet* alone gave audiences about six hundred words that, according to all other evidence, they had never heard before.

Among the words first found in Shakespeare are *abstemious*, *antipathy*, *critical*, *frugal*, *dwindle*, *extract*, *horrid*, *vast*, *hereditary*, *critical*, *excellent*, *eventful*, *barefaced*, *assassination*, *lonely*, *leapfrog*, *indistinguishable*, *well-read*, *zany*, and countless others (including *countless*). Where would we be without them? He was particularly prolific, as David Crystal points out, when it came to attaching *un-* prefixes to existing words to make new words that no one had thought of before—*unmask*, *unhand*, *unlock*, *untie*, *unveil* and no fewer than 309 others in a similar vein. Consider how helplessly prolix the alternatives to any of these terms are and you appreciate how much punch Shakespeare gave English.

He produced such a torrent of new words and meanings that a good many, as Otto Jespersen once bemusedly observed, "perhaps were not even clearly understood by the author himself." Certainly many of them failed to take hold. *Undeaf*, *untent*, and *unhappy* (as a verb), *exsufflicate*, *bepray*, and *insultment* were among those that were scarcely heard again. But a surprisingly large number did gain common currency and about eight hundred are still used today—a very high proportion. As Crystal says, "Most modern authors, I imagine, would be delighted if they contributed even one lexeme to the future of the language."

His real gift was as a phrasemaker. "Shakespeare's lan-

guage," says Stanley Wells, "has a quality, difficult to define, of memorability that has caused many phrases to enter the common language." Among them: *one fell swoop, vanish into thin air, bag and baggage, play fast and loose, go down the primrose path, be in a pickle, budge an inch, the milk of human kindness, more sinned against than sinning, remembrance of things past, beggar all description, cold comfort, to thine own self be true, more in sorrow than in anger, the wish is father to the thought, salad days, flesh and blood, foul play, tower of strength, be cruel to be kind, blinking idiot, with bated breath, tower of strength, pomp and circumstance, foregone conclusion*—and many others so repetitiously irresistible that we have debased them into clichés. He was so prolific that he could (in *Hamlet*) put two in a single sentence: "Though I am native here and to the manner born, it is a custom more honoured in the breach than the observance."

If we take the *Oxford Dictionary of Quotations* as our guide, then Shakespeare produced roughly one-tenth of all the most quotable utterances written or spoken in English since its inception—a clearly remarkable proportion.

Yet curiously English was still struggling to gain respectability. Latin was still the language of official documents and of serious works of literature and learning. Thomas More's *Utopia*, Francis Bacon's *Novum Organum*, and Isaac Newton's *Principia Mathematica* were all in Latin. The Bodleian Library in Oxford in 1605 possessed almost six thousand books. Of these, just thirty-six were in English. Attachment to Latin was such that in 1568 when one Thomas Smith produced the first textbook on the English language, he wrote it in Latin.

Thanks in no small measure to the work of Shakespeare and his fellows, English was at last rising to preeminence in the country of its creation. "It is telling," observes Stanley Wells, "that William Shakespeare's birth is recorded in Latin but that he dies in English, as 'William Shakespeare, gentleman.'"

Chapter Six

Years of Fame, 1596–1603

N OT FROM ALL PERSPECTIVES were Elizabeth's clos-
ing years a golden age. The historian Joyce Youings calls
the belief in an Elizabethan ecstasy "part of the folklore of the
English-speaking peoples," and adds that "few people alive in
the 1590s in an England racked by poverty, unemployment and
commercial depression would have said that theirs was a better
world or that human inventiveness had restored a good and just
society."

Plague had left many families headless and without sup-
port, and wars and other foreign adventures had created an in-
digent subclass of cripples and hobbling wounded, all virtually
unpensioned. It was not an age in which much consideration
was given to the weak. At just the time that he was making a
fortune in London, Sir Thomas Gresham was also systemati-
cally evicting nearly all the tenants from his country estates in
County Durham, condemning them to the very real prospect

of starvation, so that he could convert the land from arable to grazing and enjoy a slightly improved return on his investment. By such means did he become the wealthiest commoner in Britain.

Nature was a great culprit, too. Bad harvests created shortages that sent prices soaring. Food riots broke out in London, and troops had to be called in to restore order. "Probably for the first time in Tudor England, large numbers of people in certain areas died of starvation," writes Youings. Malnutrition grew chronic. By 1597 the average wage was less than a third (in real terms) of what it had been a century before. Most of the staple foods of the poor—beans, peas, cereals of all types—had doubled in price from four years earlier. A loaf of bread still cost a penny, but where a penny had once bought a loaf weighing over three and a half pounds, by 1597 the standard loaf had shrunk to just eight ounces, often bulked out with lentils, mashed acorns, and other handy adulterants. For laborers, according to Stephen Inwood, this was not just the worst year in a long time, it was the worst year in history.

It is a wonder that any working person could afford a trip to the theater, yet nearly all relevant contemporary accounts make clear that the theater was robustly popular with the laboring classes throughout the depressed years. Quite how they managed it, even when employed, is a mystery because in sixteenth-century London working people really worked—from 6 a.m. to 6 p.m. in winter and till 8 p.m. in summer. Since plays were performed in the middle of that working day, it wouldn't seem self-evidently easy for working people to get away. Somehow they did.

For Shakespeare there was a personal dimension to the gloom of the decade. In August 1596 his son, Hamnet, aged eleven, died in Stratford of causes unknown. We have no idea how Shakespeare bore this loss, but if ever there was a moment when we can glimpse Shakespeare the man in his plays, surely it is in these lines, written for *King John* probably in that year:

> *Grief fills the room up of my absent child,*
> *Lies in his bed, walks up and down with me,*
> *Puts on his pretty looks, repeats his words,*
> *Remembers me of all his gracious parts,*
> *Stuffs out his vacant garments with his form.*

But then it is also the case, as the theater historian Sir Edmund Chambers long ago noted, that "in the three or four years following his loss Shakespeare wrote his happiest work: he created Falstaff, Prince Hal, King Henry V, Beatrice and Benedick, Rosalind and Orlando. Then came Viola, Sir Toby Belch and Lady Belch." It is a seemingly irreconcilable contradiction.

Whatever his mood, for Shakespeare this was a period of increasing fame and professional good fortune. By 1598 his name had begun to appear on the title pages of the quarto editions of his plays—a sure sign of its commercial value. This was also the year in which Francis Meres remarked upon him in admiring terms in *Palladis Tamia*. In 1599 a volume of poetry called *The Passionate Pilgrim* was published with Shakespeare's name on the title page even though he contributed (probably

involuntarily) only a pair of sonnets and three poetic passages from *Love's Labour's Lost*. A little later (the date is not certain) a play called *The Return from Parnassus: Part I* was performed by students at Cambridge and contained the words "O sweet Mr Shakespeare! I'll have his picture in my study at the court," suggesting that Shakespeare was by then a kind of literary pinup.

The first nontheatrical reference to Shakespeare in London comes during this period, too, and is entirely puzzling. In 1596 he and three others—Francis Langley, Dorothy Soer, and Ann Lee—were placed under court order to keep the peace after one William Wayte brought charges that he stood in "fear of death" from them. Langley was the owner of the Swan Theatre, and thus in the same line of business as Shakespeare, though as far as we know the two never worked together. Who the women were is quite unknown; despite much scholarly searching, they have never been identified or even plausibly guessed at. The source of the friction between these people, and what role Shakespeare had in it, is equally uncertain.

Wayte, it is known, was an unsavory character—he was described in another case as a "loose person of no reckoning or value"—but what exactly his complaint was is impossible to say. The one thing all the parties had in common was that they lived in the same neighborhood, so it may be, as Schoenbaum suggests, that Shakespeare was simply an innocent witness drawn into two other men's dispute. It is, in any case, a neat illustration of how little we know of the details of Shakespeare's life, and how the little we do know seems always to add to the mystery rather than lighten it.

A separate question is why Shakespeare moved in this period to Bankside, a not particularly salubrious neighborhood, when his theatrical connection was still with the Theatre, at precisely the other side of the City. It must have been a slog shuttling between the two (and with the constant risk of finding his way barred when the City gates were locked each dusk), for Shakespeare was a busy fellow at this time. As well as writing and rewriting plays, memorizing lines, advising at rehearsals, performing, and taking an active interest in the business side of the company, he also spent much time engaged in private affairs—lawsuits, real-estate purchases, and, it seems all but certain, trips back home.

Nine months after Hamnet's death, in May 1597, Shakespeare bought a grand but mildly dilapidated house in Stratford, on the corner of Chapel Street and Chapel Lane. New Place was the second biggest dwelling in town. Built of timber and brick, it had ten fireplaces, five handsome gables, and grounds large enough to incorporate two barns and an orchard. Its exact appearance in Shakespeare's time is uncertain because the only likeness we have of it is a sketch done almost a century and a half later, from memory, by one George Vertue, but it was certainly an imposing structure. Because the house was slightly decrepit Shakespeare got it for the very reasonable price of £60—though Schoenbaum cautions that such figures were often a fiction, designed to evade duties, and an additional undeclared cash payment may also have been involved.

In only a little over a decade, William Shakespeare had

clearly become a man of substance—a position he underscored by securing (in his father's name and at no small cost to himself) a coat of arms, allowing father and son and all their heirs in perpetuity to style themselves gentlemen—even though the death of Hamnet meant that there would be no male heirs now. Seeking a coat of arms might seem from our perspective a rather shallow, arriviste gesture, and perhaps it was, but it was a common enough desire among theatrical types. John Heminges, Richard Burbage, Augustine Phillips, and Thomas Pope all also sought and were granted coats of arms and the entitlement to respect that went with them. We should perhaps remember that these were men whose careers were founded on the fringes of respectability at a time when respectability meant a good deal.

John Shakespeare didn't get to enjoy his gentlemanly privileges long. He died in 1601, aged about seventy, having been a financial failure by this point for a quarter of a century—more than a third of his life.

Quite how well off Shakespeare became in these years is impossible to say. Most of his income came from his share of ownership of the theatrical company. From the plays themselves he would have earned comparatively little—about £6 was the going rate for a finished script in Shakespeare's day, rising perhaps to £10 for a work of the first rank. Ben Jonson in a lifetime earned less than £200 from his plays, and Shakespeare wouldn't have made a great deal more.

Various informed estimates suggest that his earnings in his peak years were not less than £200 a year and may have been as much as £700. On balance Schoenbaum thinks the lower

figure more likely to be correct, and Shakespeare wouldn't always have achieved that. In plague years, when the theaters were closed, all theatrical earnings were bound to have been much reduced.

Still, there is no question that he was by his early thirties a respectably prosperous citizen—though we gain a little perspective on Shakespeare's wealth when we compare his £200 to £700 a year with the £3,300 that the courtier James Hay could spend on a single banquet or the £190,000 that the Earl of Suffolk lavished on his country home in Essex, Audley End, or the £600,000 in booty Sir Francis Drake brought home from just one productive sea venture in 1580. Shakespeare was well off but scarcely a titan of finance. And it appears that no matter how prosperous he got, he never stopped being tightfisted. In the same year that he bought New Place, he was found guilty in London of defaulting on a tax payment of 5 shillings; the following year he defaulted again.

Though it isn't possible to say how much time he spent in Stratford in these years, it is certain that he became a presence in the town as an investor and occasional litigant. And it is apparent that he was known by his neighbors as a man of substance. In October 1598 Richard Quiney of Stratford (whose son would eventually marry one of Shakespeare's daughters) wrote to Shakespeare asking for a loan of £30—roughly £15,000 in today's money, so no small sum. In the event, it appears Quiney had second thoughts or was somehow deflected from his course, for the letter seems never to have been sent. It was found among his papers at his death.

Rather oddly, this period when Shakespeare was displaying wealth in an unusually debonair manner coincided with what must have been a financially uncertain period for the Lord Chamberlain's Men. In January 1597 James Burbage, their guiding light and most senior figure, died at the age of sixty-seven, just as the company's lease on the Theatre was about to expire. Burbage had recently invested a great deal of money—£1,000 at least—in purchasing and refurbishing the old Blackfriars Monastery in the City with the intention of turning it into a theater. Unfortunately the residents of the neighborhood had successfully petitioned to stop his plan.

James Burbage's son Cuthbert pursued negotiations to renew the Theatre's lease—normally a straightforward process—but the landlord proved difficult and strangely evasive. The likelihood is that he had other plans for the site and the building that stood upon it. After a year of getting nowhere with him, the men of the company decided to take action.

On the night of December 28, 1598, the Lord Chamberlain's Men, aided by a dozen or so workmen, secretly began to dismantle the Theatre and conveyed it across the frozen Thames, where it was reerected overnight, according to legend. In fact (and not surprisingly) it took considerably more than a single night, though exactly how long is a matter of persistent dispute. The contract for the construction of the rival Fortune Theatre indicates a building time of six months, suggesting that the new theater is unlikely to have been ready before summer at the earliest (just the time when the London theatrical season came to an end).

The new Globe, as it came to be called, stood a hundred feet or so in from the river and a little west of London Bridge and the palace of the bishops of Westminster. (The replica Globe Theatre built in 1997 is not on the original site, as visitors often naturally suppose, but merely near it.) Although Southwark is generally described as a place of stews, footpads, and other urban horrors, it is notable that in both Visscher's and Hollar's drawings much of the district is quite leafy and that the Globe is shown standing on the edge of serene and pleasant fields, with cows grazing right up to its walls.

The members of Shakespeare's company owned the Globe among them. The land for the theater was leased in February 1599 for thirty-one years to Cuthbert Burbage and his brother Richard and to five other members of the troupe: Shakespeare, Heminges, Augustine Phillips, Thomas Pope, and Will Kemp. Shakespeare's share varied over time—from one-fourteenth of the whole to one-tenth—as other investors bought in or sold off.

The Globe is sometimes referred to as "a theatre built by actors for actors" and there is of course a good deal in that. It is famously referred to as "this wooden O" in *Henry V*, and other contemporary accounts describe it as round, but it is unlikely to have been literally circular. "Tudor carpenters did not bend oak," the theater historian Andrew Gurr has observed, and a circular building would have required bent wood. Instead it was probably a many-sided polygon.

The Globe had a distinction in that it was designed exclusively for theatrical productions and took no earnings from

cockfighting, bearbaiting, or other such common entertainments. The first mention of it in writing comes in the early autumn of 1599 when a young Swiss tourist named Thomas Platter left a pretty full account of what he saw—including, on September 21, a production of *Julius Caesar* at the Globe, which he said was "very pleasingly performed" by a cast of about fifteen players. It is the first mention not only of the Globe, but also of *Julius Caesar*. (We are much indebted to Platter and his diary for a large part of what we know about Elizabethan theatrical performances in London—making it all the more ironic that he spoke almost no English and could not possibly have understood most of what he was seeing.)

The new theater immediately outshone its chief competitor, the Rose, home of Edward Alleyn and the Admiral's Men. The Rose was only a stroll away down a neighboring lane, and only seven years old, but it was built on boggy ground that made it always dank and uncomfortable. Unable to compete, Alleyn's company retired to a new site across the river, on Golden Lane, Cripplegate Without, where they built the Fortune, which was even larger than the Globe. It is the one London theater of the period for which architectural details exist, and so most of our "knowledge" of the Globe is in fact extrapolated from it. It burned down in two hours in 1621, leaving the Admiral's Men "utterly undone."

The Globe itself didn't last long. It likewise burned down in 1613, when sparks from a stage cannon ignited the roof thatch. But what a few years they were. No theater—perhaps no human enterprise—has seen more glory in only a decade or so than the

Globe during its first manifestation. For Shakespeare this period marked a burst of creative brilliance unparalleled in English literature. One after another, plays of unrivaled majesty dropped from his quill: *Julius Caesar, Hamlet, Twelfth Night, Measure for Measure, Othello, King Lear, Macbeth, Antony and Cleopatra.*

We thrill at these plays now. But what must it have been like when they were brand new, when all their references were timely and sharply apt, and all the words never before heard? Imagine what it must have been like to watch *Macbeth* without knowing the outcome, to be part of a hushed audience hearing Hamlet's soliloquy for the first time, to witness Shakespeare speaking his own lines. There cannot have been, anywhere in history, many more favored places than this.

Shakespeare also at this time produced (though he may of course have written earlier) an untitled allegorical poem, which history has come to know as *The Phoenix and the Turtle*, for a book of poems published in 1601 called *Love's Martyr: or Rosalind's Complaint*, compiled by Robert Chester and dedicated to Chester's patrons, Sir John and Lady Salusbury. What relationship Shakespeare had with Chester or the Salusburys is unknown. The poem, sixty-seven lines long, is difficult and doesn't always get much notice in biographies (Greenblatt in *Will in the World* and Schoenbaum in his *Compact Documentary Life* both, rather surprisingly, fail to mention it at all) but Frank Kermode rates it highly, calling it "a remarkable work with no obvious parallel in the canon," and praising its extraordinary language and rich symbolism.

Yet—and there really is always a "yet" with Shakespeare—

just as he was feverishly turning out some of his greatest work and enjoying the summit of his success, everything in his private life seemed to indicate a pronounced longing to be in Stratford. First he bought New Place—a strikingly large commitment for someone who had not owned a home before—and followed that with a cottage and plot of land across the road from New Place (probably to house a servant; it was too small to make a rentable investment). Then he acquired 107 acres of tenanted farmland north of Stratford for £320. Then, in the summer of 1605, he spent the very substantial sum of £440 to buy a 50 percent holding in tithes of "corn, grain, blade and hay" in three neighboring villages, from which he could expect earnings of £60 a year.

In the midst of these purchases, in the early winter of 1601, Shakespeare and his fellows faced what must have been an unnerving experience when they became peripherally but dangerously involved in an attempt to overthrow the queen. The instigator of this reckless exercise was Robert Devereux, second Earl of Essex.

Essex was the stepson of the Earl of Leicester, Elizabeth's longtime favorite and consort in all but name for much of her reign. Essex, though thirty years Elizabeth's junior, was in his turn a favorite, too, but he was also headstrong, reckless, and foolishly, youthfully disobedient. Time and again he tried her patience, but in 1599 royal exasperation turned to furious displeasure when Essex, as Lord Lieutenant of Ireland, concluded a truce without authority with Irish insurgents, then returned

to England against orders. Enraged, the queen placed Essex under strict house arrest. He was forbidden to have contact with his wife or even to stroll in his own garden. Worse, he was deprived of the lucrative offices that had supported him. The confinement was lifted the following summer, but by this point the damage to his pride and pocket had been done, and he began, with a few loyal followers, to cook up a scheme to foment a popular uprising and depose the queen. Among these loyal followers was the Earl of Southampton.

It was at this point, in February 1601, that Sir Gelly Meyrick, one of Essex's agents, approached the Lord Chamberlain's Men enjoining them to present a command performance of *Richard II* for a special payment of £2. The play, according to Meyrick's specific instructions, was to be performed at the Globe, in public, and the company was expressly instructed to include the scenes in which the monarch was deposed and murdered. This was a willfully incendiary act. The scenes were already so politically sensitive at the time that no printer would dare publish them.

It is important to bear in mind that to an Elizabethan audience a history play was not an emotionally remote account of something long since done; rather, it was perceived as a kind of mirror reflecting present conditions. Therefore staging *Richard II* was bound to be seen as an intentionally and provocatively seditious exercise. Only recently a young author named John Hayward had found himself clapped into the Tower after writing sympathetically about Richard II's abdication in *The First Part of the Life and Reign of King Henry IV*—an error of

judgment he further compounded by dedicating the work to the Earl of Essex. This was no time to be trifling with regal feelings.

Yet the Lord Chamberlain's Men dutifully performed the play as commanded on February 7. The next day the Earl of Essex, supported by three hundred men, set off from his home in the Strand toward the City. His plan was first to take control of the Tower and then Whitehall and then to arrest the queen. It was a harebrained scheme. His hope, evidently, was to replace Elizabeth with James VI of Scotland, and it was his confident expectation that he would accumulate supporters along the way. In fact, no one came forward—not a soul. His men rode through eerily silent streets, their rallying cries unanswered by a sullen and watching citizenry. Without a mob behind them, they had no hope of victory. Uncertain what to do next, Essex stopped for lunch, then fell back with his small (and swiftly evaporating) army toward the Strand. At Ludgate they ran into a party of startled soldiers, who in some confusion drew weapons and managed to fire some shots. A bullet passed through Essex's hat.

His revolution descending into farce, Essex fled back to his house, where he spent what remained of his liberty trying desperately—and a little pointlessly, one would have thought—to destroy incriminating documents. Soon afterward a detachment of soldiers turned up and arrested him and his archsupporter, Southampton.

Augustine Phillips spoke for the Lord Chamberlain's Men at the investigation that followed. We know little about Phil-

lips, other than that he was a trusted member of the company, but he must have made a persuasive case that they were innocent dupes or had acted under duress, for they were excused of any transgression—in fact were summoned to stage *another* play before the queen at Whitehall on the very day that she signed Essex's death warrant, Shrove Tuesday, 1601. Essex was executed on the day following. Meyrick and five other supporters were likewise beheaded. Southampton faced a similar unhappy fate, but was spared execution thanks to his mother's influential pleadings. He spent two years imprisoned in the Tower of London, albeit in considerable comfort in a suite of apartments that cost him £9 a week in rent.

Essex would have saved his own head and a great deal of bother if only he had been born with a little patience. Just over two years after his farcical rebellion, the queen herself was dead—and swiftly succeeded by the man whom Essex had given his life to try to put on the throne.

Chapter Seven

The Reign of King James,
1603–1616

B Y THE WINTER OF 1603, if an account left by a French envoy, André Hurault, is entirely to be trusted, Queen Elizabeth I had become a little odd to behold. Her face was caked permanently in a thick mask of white makeup, her teeth were black or missing, and she had developed the distracted habit of loosening the stays of her dress so that it forever hung open. "You could see the whole of her bosom," noted Hurault in some wonder.

Shortly after Twelfth Night, the court retired to the royal palace at Richmond and there in early February the Chamberlain's Men, presumably with William Shakespeare among them, performed before the queen for the last time. (The play they performed is not known.) Soon afterward Elizabeth caught a chill and slipped into a dreamy, melancholic illness from which she never emerged. On March 24, the last day of

the year under the old Julian calendar, she died in her sleep, "mildly like a lamb." She was sixty-nine years old.

To the joy of nearly everyone, she was uneventfully succeeded by her northern kinsman James, son of Mary, Queen of Scots. He was thirty-six years old and married to a Danish Catholic, but devotedly Protestant himself. In Scotland he was James VI, but in England he became James I. He had ruled in Scotland for twenty years already and would reign in England for twenty-two more.

James was not, by all accounts, the most visually appealing of fellows. He was graceless in motion, with a strange lurching gait, and had a disconcerting habit, indulged more or less constantly, of playing with his codpiece. His tongue appeared to be too large for his mouth. It "made him drink very uncomely," wrote one contemporary, "as if eating his drink." His only concession to hygiene, it was reported, was to daub his fingertips from time to time with a little water. It was said that one could identify all his meals since becoming king from the stains and gravy scabs on his clothing, which he wore "to very rags." His odd shape and distinctive waddle were exaggerated by his practice of wearing extravagantly padded jackets and pantaloons to protect himself from assassins' daggers.

We might allow ourselves a touch of skepticism here, however. These critical observations were, in truth, mostly made by disaffected courtiers who had every reason to wish to see the king reduced by caricature, so it is difficult to know how much of a shambling wreck he really was. In one five-year period he bought two thousand pairs of gloves, and in 1604 he spent a

staggering £47,000 on jewels, which clearly doesn't suggest a total disregard for appearance.

Yet there is no doubt that there was a certain measure of differentness about him, particularly with regard to sexual comportment. Almost from the outset he excited dismay at court by nibbling handsome young men while hearing the presentations of his ministers. Yet he was also dutiful enough to produce eight children by his wife, Queen Anne. Simon Thurley notes how in 1606 James and his brother-in-law, King Christian IV of Denmark, undertook a "drunken and orgiastic progress" through the stately homes of the Thames Valley, with Christian at one point collapsing "smeared in jelly and cream." A day or two later, however, both were to be found sitting circumspectly watching *Macbeth*.

Whatever else he was, James was a generous patron of drama. One of his first acts as king was to award Shakespeare and his colleagues a royal patent, making them the King's Men. For a theatrical troupe, honors came no higher. The move made them Grooms of the Chamber and gave them the right, among other privileges, to deck themselves out in four and a half yards of scarlet cloth provided by the Crown. James remained a generous supporter of Shakespeare's company, using them often and paying them well. In the thirteen years between his accession and Shakespeare's death, they would perform before the king 187 times, more than all other acting troupes put together.

Though Shakespeare is frequently categorized as an Elizabethan playwright, in fact much of his greatest output was

Jacobean and he now produced a string of brilliant tragedies—
Othello, *King Lear*, *Macbeth*, *Antony and Cleopatra*, *Coriolanus*—
and one or two lesser works, notably *Timon of Athens*, a play so
difficult and seemingly incomplete that it is rarely performed
today. James made his own contribution to literary posterity,
too, by presiding over the production of a new "Authorized
Version"—the King James Version—of the Bible, a process
which took a panel of worthies seven years of devoted labor
from 1604 to 1611 to complete and in which he took an in-
formed and leading interest. It was the one literary production
of the age that rivaled Shakespeare's for lasting glory—and,
not incidentally, played a more influential role in encouraging
a conformity of spelling and usage throughout Britain and its
infant overseas dominions.

By the reign of James, comparatively few Britons were any
longer truly Catholic. Whereas Shakespeare had been born
into a country that was probably (albeit discreetly) two-thirds
Roman Catholic, by 1604 few people alive had ever heard a
Mass or taken part in any Catholic rite. Perhaps as little as 2
percent of the populace (though a higher proportion of aris-
tocrats) were actively Catholic. Thinking it was safe to do so,
in 1604 James suspended the recusancy laws and even allowed
Mass to be said in private homes.

In fact the severest Catholic challenge to Protestant rule
was just about to be mounted, when a group of conspirators
placed thirty-six barrels of gunpowder—ten thousand pounds
or so by weight—in a cellar beneath the Palace of Westminster
in advance of the state opening of Parliament. Such a volume of

explosives would have been sufficient to blow the palace, West-minster Abbey, Westminster Hall, and much of the surrounding neighborhood sky-high, taking with it the king, queen, their two sons, and most of the nation's leading clerics, aristo-crats, and distinguished commoners. The reverberations from such an event are essentially unimaginable.

The one drawback of the scheme was that it would in-evitably kill innocent Catholic parliamentarians. In the hope of sparing them, an anonymous tip-off was sent to a lead-ing Catholic, Lord Monteagle. Hopelessly compromised and fearing an excruciating reprisal, Monteagle handed the letter straight to the authorities, who entered the palace's cellar and found one Guy Fawkes sitting on the barrels, waiting for the signal to strike a light. November 5 has been celebrated ever since with the burning of Fawkes effigies, though the hapless Fawkes was in fact a comparatively minor figure in the Powder Treason, as it became known at the time. The mastermind was Robert Catesby, whose family owned an estate just twelve miles from Stratford and who was distantly related to William Shakespeare by marriage, though there is no suggestion that their lives ever meaningfully intersected. In any case Catesby had spent most of his adult life as a faithful Protestant and had reverted to Catholicism only with the death of his wife five years earlier.

The reaction against Catholics was swift and decisive. They were barred from key professions and, for a time, not permit-ted to travel more than five miles from home. A law was even proposed to make them wear striking and preposterous hats,

for ease of identification, but it was never enacted. Recusancy fines, however, were reinstated and fiercely enforced. Catholicism would never be a threat in England again. The challenge to orthodoxy now would come from the other end of the religious spectrum—from the Puritans.

Though Shakespeare was increasingly a person of means, and now one of the most conspicuous men of property in Stratford, surviving evidence shows that in London he continued to live frugally. He remained in lodgings, and the value of his worldly goods away from Stratford was assessed by tax inspectors at a modest £5. (But a man as pathologically averse to paying taxes as Shakespeare no doubt took steps to minimize any appearance of wealth.)

Thanks to the scrupulous searching of Charles and Hulda Wallace and the documents of the Belott-Mountjoy case, we know that Shakespeare in this period was living in the home of the Huguenot Christopher Mountjoy, on the corner of Silver and Monkswell streets in the City—though he may not have been there continuously, as plague once again shut the theaters in London for a year, from May 1603 to April 1604. It was also during this period, as may be remembered, that Mountjoy fell out with his son-in-law Stephen Belott over the financial settlement concerning Belott's marriage to Mountjoy's daughter—a matter that must have generated a good deal of heat in the household, judging by the later depositions. It is diverting to imagine a tired and no doubt overstressed William Shakespeare trying to write *Measure for Measure* or *Othello* (both probably

written that year) in an upstairs room over a background din of family arguments. But of course he may have written elsewhere. And the Belotts and Mountjoys may have fought their wars in whispers. We know that one of their other lodgers, a writer named George Wilkins, was a man of violent temper, so perhaps they were too cowed to raise their voices.

The reknowned Shakespeare authority Stanley Wells thinks Shakespeare might have taken time off from the company to return to Stratford to write plays. "He retained a close interest in Stratford throughout his life, and there is nothing to suggest that he didn't retire there from time to time to write in peace," Wells told me. "The company may well have said to him, 'We need a new play—go home and write it.' He owned a rather grand establishment. It is not unreasonable to suppose that he might have wanted to spend time there."

Except that he was creatively productive, nothing of note can be stated with certainty about Shakespeare's life from 1603 to 1607 and 1608, when first his brother Edmund and then his mother died, both of unknown causes. Edmund was twenty-seven years old and an actor in London. Shakespeare's mother was over seventy—a ripe old age. More than that we do not know about either of them.

In the same year that Shakespeare's mother died, the King's Men finally secured permission to open the Blackfriars Theatre. The Blackfriars became the template from which all subsequent indoor theaters evolved, and so ultimately was more important to posterity than the Globe. It held only about six hundred people, but it was more profitable than the Globe because the

price of admission was high: sixpence for even the cheapest seat. This was good news for Shakespeare, who had a one-sixth interest in the operation. The smaller theater also permitted a greater intimacy in voice and even in music—strings and woodwinds rather than trumpet blasts.

Windows admitted some light, but candles provided most of the illumination. Spectators could, for an additional fee, sit on the stage—something not permitted at the Globe. With stage seating, audience members could show off their finery to maximum effect, and the practice was lucrative; but it contained an obvious risk of distraction. Stephen Greenblatt relates an occasion in which a nobleman who had secured a perch on the stage spied a friend entering across the way and strode *through* the performance to greet him. When rebuked by an actor for his thoughtlessness, the nobleman slapped the impertinent fellow and the audience rioted.

Apart from the stage itself, the best seats were in the pit (or so it is presumed) because the hanging candelabra must at least partly have obscured the view of those sitting higher up. With the Blackfriars up and running, the Globe closed for the winter.

On May 20, 1609, a quarto volume titled *Shakespeare's Sonnets, Never Before Imprinted*, went on sale, priced at 5 pence. The publisher was one Thomas Thorpe; this was slightly unexpected, as he possessed neither a press nor retail premises. What he did have, however, were the sonnets. Where he got them, and what William Shakespeare made of his having them, can only

be guessed at. We have no record of Shakespeare's making any public reaction to the sonnets' publication.*

"Probably more nonsense has been talked and written, more intellectual and emotional energy expended in vain, on the sonnets of Shakespeare than on any other literary work in the world," said W. H. Auden, correctly. We know virtually nothing for certain about them—when they were written, to whom they were addressed, under what circumstances they came to be published, whether they are assembled in even remotely the correct order.

In some critics' view, the sonnets are the very summit of Shakespeare's achievement. "No poet has ever found more linguistic forms by which to replicate human responses than Shakespeare in the Sonnets," wrote the Harvard professor Helen Vendler in *The Art of Shakespeare's Sonnets*. "The greater sonnets achieve an effortless combination of imaginative reach with high technical invention . . . a quintessence of grace."

Certainly they contain some of his most celebrated lines, as in the opening quatrain to Sonnet 18:

* A sonnet is a fourteen-line poem perfected by Petrarch (Francesco Petrarca), the fourteenth-century Italian poet. The word comes from *sonetto*, or "little song." The Italian sonnet of Petrarch was divided into two parts—an eight-line octave with one rhyme scheme (*abba, abba*) and a six-line sestet with another (*cde, cde* or *cdc, dcd*). In England the sonnet evolved a different form, and came to consist of three quatrains and a rather more pithy couplet at the end as a kind of kicker, and with it came a distinctive rhyme scheme: *abab, cdcd, efef, gg*.

Shall I compare thee to a summer's day?
Thou art more lovely and more temperate.
Rough winds do shake the darling buds of May,
And summer's lease hath all too short a date

What is unusual about these lines, and many others of an even more direct and candid nature, is that the person they praise is not a woman but a man. The extraordinary fact is that Shakespeare, creator of the tenderest and most moving scenes of heterosexual affection in play after play, became with the sonnets English literary history's sublimest gay poet.

Sonnets had had a brief but spectacular vogue, set off by Philip Sidney's *Astrophil and Stella* in 1591, but by 1609 they were largely out of fashion, and this doubtless helps to explain why Shakespeare's volume was not more commercially successful. Though his two long poems sold well, the sonnets seem to have attracted comparatively little notice and were reprinted only once in the century of their publication.

As published, the 154 sonnets are divided into two unequal parts: 1 to 126, which address a beauteous young man (or possibly even men), traditionally known as the fair youth, with whom the poet is candidly infatuated; and 127 to 154, which address a "dark lady" (though at no point is she actually so called) who has been unfaithful to him with the adored fellow in Sonnets 1 to 126. (At the risk of becoming parenthetically annoying, it is perhaps worth noting that Sonnet 126 is not strictly a sonnet but a collection of rhymed couplets.) There is also a shadowy figure known often as "the rival poet." The

volume also included, as a kind of coda, an unrelated poem, not in sonnet form, called *A Lover's Complaint*. It has many words (eighty-eight by one count) not found elsewhere in Shakespeare, leading some to suspect that it is not really his.

Many authorities believe that Shakespeare was alarmed and surprised—"horrified" in Auden's view—to find the sonnets in print. Sonnets are normally celebrations of love, but these were often full of self-loathing and great bitterness. Many were also arrestingly homoerotic, with references to "my lovely boy," "the master mistress of my passion," "Lord of my love," "thou mine, I thine," and other such bold and dangerously unorthodox declarations. It was irregular, to say the least, to address a love poem to someone of the same sex. The king's behavior at court notwithstanding, homosexuality was not a sanctioned activity in Stuart England and sodomy was still technically a capital offense (though the rarity of prosecutions suggests that it was quietly tolerated).

Nearly everything about the sonnets is slightly odd, starting with the dedication, which has bewildered and animated scholars almost since the moment of publication. It reads: "To the onlie begetter of these ensuing sonnets Mr W.H. all happinesse and that eternitie promised by our ever-living poet, wisheth the well-wishing adventurer in setting forth." It is signed "T.T".—which is reasonably taken to be Thomas Thorpe—but who is the enigmatic "Mr W.H."? One candidate, suggested surprisingly often, is Henry Wriothesley, with his initials reversed (for reasons no one has ever remotely made sound convincing). Another is William Herbert, third Earl of Pembroke, whose

initials are at least in order and who had a Shakespeare connection: Heminges and Condell would dedicate the First Folio to him and his brother fourteen years later.

The problem with either of these candidates is that they were both aristocratic, while the dedicatee is addressed here as "Mr." It has been suggested that Thorpe may not have known any better, but in fact Thorpe addressed Pembroke directly in a separate volume in the same year and did so with the usual obsequious flourishes: "To the Right Honourable, William, Earl of Pembroke, Lord Chamberlain to his Majesty, one of his most honourable Privy Council, and Knight of the most noble order of the Garter, etc. . . ." Thorpe knew how to address a noble. A more prosaic likelihood is that "Mr W.H." was a stationer named William Hall, who, like Thorpe, specialized in unauthorized productions.

A separate matter of contention is whether the "onlie begetter" is the person being addressed in the sonnets or simply the one who procured the text—whether he supplied the inspiration or merely the manuscript. Most authorities think the latter, but the dedication is vague to the point of real oddness. "Indeed," Schoenbaum wrote, "the entire dedication . . . is so syntactically ambiguous as to defeat any possibility of consensus among interpreters."

We don't know when Shakespeare wrote his sonnets, but he employed sonnets in *Love's Labour's Lost*—one of his very earliest plays by some reckonings—and in *Romeo and Juliet*, where a conversation between the two lovers is ingeniously (and movingly) rendered in sonnet form. So the sonnet as a poetic ex-

pression was certainly on his mind in the early to mid-1590s, at about the time he might have had a relationship with Southampton (assuming he had one). But dating the sonnets is an exceedingly tricky business. A single line in Sonnet 107 ("The mortal moon hath her eclipse endured") has been taken to signify at least five separate historic occurrences: an eclipse, the death of the queen, an illness of the queen, the defeat of the Spanish Armada, or a reading from a horoscope. Other sonnets seem to have been written earlier still. Sonnet 145 contains a pun on the name "Hathaway" ("'I hate' from hate away she threw"), which suggests that he may have written it in Stratford when he was in courting mode. If Sonnet 145 is indeed really autobiographical, it also makes clear that Shakespeare was not an innocent seduced by an older woman, but was rebuffed and had to work hard to win her heart.

The sonnets have driven scholars to the point of distraction because they are so frankly confessional in tone and yet so opaque. The first seventeen all urge the subject to marry, prompting biographers to wonder if they weren't directed at Southampton, who was, as we know, a most reluctant bridegroom. The poems press the fair youth to propagate so that his beauty is passed on—an approach that might well have appealed both to Southampton's vanity and to his sense of his genealogical responsibilities as an aristocrat. One suggestion is that Shakespeare was commissioned (by Burleigh or Southampton's mother or both) to write the poems, and that during the course of this transaction he met and fell for Southampton and the so-called dark lady.

It is an appealing scenario but one based on nothing but a chain of hopeful suppositions. We have no evidence that Shakespeare had even a formal acquaintance with Southampton, much less a panting one. It must also be said that the few specific references to appearance in the sonnets don't always sit comfortably with the known facts. Southampton, for example, was inordinately proud of his auburn hair, yet the admired character in Shakespeare has "golden tresses."

Looking for biography—Shakespeare's or anyone's—in the sonnets is almost certainly an exercise in futility. In fact, we don't actually know that the first 126 sonnets are all addressed to the same young man—or indeed that in every instance the person *is* a man. Many of the sonnets do not indicate the sex of the person being addressed. It is only because they have been published as a sequence—probably an unauthorized one—that we take them to be connected.

"If we take the 'I' in every sonnet to be stable, that's an enormous conceit," Paul Edmondson of the Shakespeare Birthplace Trust and coauthor with Stanley Wells of the book *Shakespeare's Sonnets* told me on a visit to Stratford. "People tend too easily to suppose they are printed as written. We just don't know that. Also, the 'I' doesn't have to be Shakespeare's own voice; there might be lots of different imaginary 'I's. Many of the conclusions about gender are based simply on context and placement." He notes that only twenty of the sonnets can conclusively be said to concern a male subject and just seven a female.

The dark lady is no less doubtful. A. L. Rowse—who, it must be said, never allowed an absence of certainty to get in the

way of a conclusion—in 1973 identified the dark lady as Emilia Bassano, daughter of one of the queen's musicians, and, with a certain thrust of literary jaw, asserted that his conclusions "cannot be impugned, for they are the answer," even though they are unsupported by anything that might reasonably be termed proof. Another oft-mentioned candidate was Mary Fitton, mistress of the Earl of Pembroke. But again some imagery in the text—"her breasts are dun; . . . / black wires grow on her head"—suggests someone darker still.

We will almost certainly never know for sure, and in any case we perhaps don't need to. Auden for one believed that knowing would add nothing to the poems' satisfactions. "Though it seems to me rather silly to spend much time on conjectures which cannot be proved true or false," he wrote, "what I really object to is their illusion that, if they were successful, if the identity of the Friend, the Dark Lady, the Rival Poet, etc., could be established beyond doubt, this would in any way illuminate our understanding of the sonnets themselves."

The matter of Shakespeare's sexuality—both that he had some and that it might have been pointed in a wayward direction—has caused trouble for his admirers ever since. One early editor of the sonnets solved the problem simply by making all the masculine pronouns feminine, at a stroke banishing any hint of controversy. Predictably, the Victorians suffered the acutest anxieties. Many went into a kind of obstinate denial and persuaded themselves that the sonnets were simply "poetical exercises" or "professional trials of skill," as the biographer Sidney

Lee termed them, arguing that Shakespeare had written them in a number of assumed voices, "probably at the suggestion of the author's intimate associates." Thus, any reference to longing to caress a fellow was Shakespeare writing in a female voice, as a demonstration of his versatility and genius. Shakespeare's real friendships, Lee insisted, were of "the healthy manly type" and any alternative interpretation "casts a slur on the dignity of the poet's name which scarcely bears discussion."

Discomfort lasted well into the twentieth century. Marchette Chute, in a popular biography of 1949, relegated all discussion of the sonnets to a brief appendix in which she explained: "The Renaissance used the violent, sensuous terms for friendship between men that later generations reserved for sexual love. Shakespeare's use of terms like 'master-mistress' sounds abnormal to the ears of the twentieth century, but it did not sound so at the end of the sixteenth." And that was as close as she or most other biographers cared to get to the matter. The historian Will Durant as recently as 1961 noted that Sonnet 20 contained "an erotic play on words" but could not bring himself to share specifics.

We needn't be so blushing. The lines he alludes to are: "But since she pricked thee out for women's pleasure, / Mine be thy love, and thy love's use their treasure." Most critics believe that these lines indicate that Shakespeare's attachment to the fair youth was never consummated. But as Stanley Wells notes, "If Shakespeare himself did not, in the fullest sense of the word, love a man, he certainly understood the feelings of those who do."

Perhaps the biggest question of all is, if he didn't write them for publication, what were they for? The sonnets represent a huge amount of work, possibly over a period of years, and at the highest level of creation. Were they really meant not to be shared? Sonnet 54 boasts:

> *Not marble nor the gilded monuments*
> *Of princes shall outlive this powerful rhyme.*

Did Shakespeare really believe that a sonnet scratched on paper and hidden away in a folder or drawer would out-last marble? Perhaps it all was an elaborate conceit or private amusement. More than for any other writer, Shakespeare's words stand separate from his life. This was a man so good at disguising his feelings that we can't ever be sure that he had any. We know that Shakespeare used words to powerful effect, and we may reasonably presume that he had feelings. What we don't know, and can barely even guess at, is where the two intersected.

In his later years Shakespeare began to collaborate—probably with George Wilkins in about 1608 on *Pericles* and with John Fletcher on *The Two Noble Kinsmen*, *Henry VIII* (or *All Is True*), and the lost play *The History of Cardenio*, all first performed around 1613. Wilkins was, on the face of it, an exceedingly unappealing character. He ran an inn and brothel and was constantly in trouble with the law—once for kicking a pregnant woman in the belly and on another occasion for beating and

stamping upon a woman named Judith Walton. But he was also an author of distinction, writing plays successfully on his own—his *Miseries of Enforced Marriage* was performed by the King's Men in 1607—and in collaboration. All that is known of his relationship with Shakespeare is that they were fellow lodgers for a time at the Mountjoy residence.

Fletcher was of a more refined background altogether. Fifteen years younger than Shakespeare, he was the son of a bishop of London (who had, among other distinctions, been the presiding cleric at the execution of Mary, Queen of Scots). Fletcher's father was for a time a favorite of Queen Elizabeth's, but after his first wife died he earned the queen's displeasure with a hasty remarriage and was banished from court. He died in some financial distress.

Young Fletcher was educated at Cambridge. As a playwright—and indeed as a person—he was most intimately associated with Francis Beaumont, with whom he enjoyed a strikingly singular relationship. From 1607 to 1613 they were virtually inseparable. They slept in the same bed, shared a mistress, and even dressed identically, according to John Aubrey. During this period they cowrote ten or so plays, including *The Maid's Tragedy* and the very successful *A King and No King*. But then Beaumont abruptly married, and the partnership just as abruptly ceased. Fletcher went on to collaborate with many others, notably Philip Massinger and William Rowley.

Nothing is known of the relationship between Shakespeare and Fletcher. It may well be that they worked separately, or it may be that Fletcher was given unfinished manuscripts to com-

plete after Shakespeare's retirement. Wells, however, thinks that the careful flow of the plays suggests they worked together closely.

The Two Noble Kinsmen, though almost certainly performed while Shakespeare was still alive, is unknown before 1634, when it was published with a title page attributing it jointly to Fletcher and Shakespeare. *Henry VIII* and *Cardenio* are also ascribed to Fletcher and Shakespeare jointly. *Cardenio* was based on a character in Don Quixote and was never published, it seems, though it was registered for publication in 1653 as being by "Mr Fletcher and Shakespeare." A manuscript copy of the play is thought to have been held by a museum in Covent Garden, London, but unfortunately the museum went up in flames in 1808 and took the manuscript with it. Fletcher died in 1625 of the plague and was buried with—literally with—his fellow playwright and sometime collaborator Massinger. Today they lie in the chancel of Southwark Cathedral beside the grave of Shakespeare's young brother Edmund.

Shakespeare may also have collaborated much earlier on *Edward III*, published anonymously in 1596. Some authorities think at least some of the play is Shakespeare's, though the matter is much in dispute. *Timon of Athens* was probably written with Thomas Middleton. Stanley Wells suggests a date of 1605, while stressing that it is very uncertain. George Peele is also mentioned often as a probable collaborator on *Titus Andronicus*.

"Shakespeare became a different kind of writer as he got older—still brilliant, but more challenging," Stanley Wells told

me in an interview. "His language became more dense and elliptical. He became less inclined to consider the needs and interests of the traditional audience. The plays became less theatrical, more introverted. He was perhaps a bit out of fashion in his last years. Even now his later plays—*Cymbeline*, *The Winter's Tale*, *Coriolanus*—are less popular than those of his middle period."

His output was clearly declining in pace. He seems to have written nothing at all after 1613, the year the Globe burned down. But he did still evidently make trips to London. In 1613, he bought a house in Blackfriars for the very substantial sum of £140, evidently as an investment. Interestingly he made the purchase more complicated than necessary by taking out a mortgage that involved the oversight of three trustees—his colleague John Heminges, his friend Thomas Pope, and William Johnson, landlord of the famous Mermaid Tavern. (This is, incidentally, the only known connection Shakespeare had to that famous tavern, legend notwithstanding.) One consequence of making the purchase in this way was that it kept the property from passing to Shakespeare's widow, Anne, upon his death. Instead it went to the trustees. Why Shakespeare would wish this, as so much else, can only be a matter for conjecture.

Chapter Eight

Death

I N LATE MARCH 1616, William Shakespeare made some changes to his will. It is tempting to suppose that he was unwell and probably dying. Certainly he appears not to have been himself. His signatures are shaky and the will bears certain signs of confusion: He could not evidently recall the names of his brother-in-law Thomas Hart or of one of Hart's sons—though it is equally odd that none of the five witnesses supplied these details either. Why, come to that, Shakespeare required that many witnesses is a puzzle. Two was the usual number.

It was an unhappily eventful time in Shakespeare's life. A month earlier his daughter Judith had married a local vintner of dubious character named Thomas Quiney. Judith was thirty-one years old and her matrimonial prospects were in all likelihood fading swiftly. In any case she appears to have chosen poorly, for just over a month after their marriage Quiney was fined 5 shillings for unlawful fornication with one Margaret

Wheeler—a very considerable humiliation for his new bride and her family. Worse, Miss Wheeler died giving birth to Quiney's child, adding tragedy to scandal.

As if this weren't enough, on April 17 Will's brother-in-law Hart, a hatter, died, leaving his sister Joan a widow. Six days later William Shakespeare himself died from causes unknown. Months don't get much worse than that.

Shakespeare's will resides today in a box in a special locked room at Britain's National Archives at Kew in London. The will is written on three sheets of parchment, each of a different size, and bears three of Shakespeare's six known signatures, one on each page. It is a strikingly dry piece of work, "absolutely void of the least particle of that Spirit which Animated Our great Poet," wrote the Reverend Joseph Greene of Stratford, the antiquary who rediscovered the will in 1747 and was frankly disappointed in its lack of affection.

Shakespeare left £350 in cash plus four houses and their contents and a good deal of land—worth a little under £1,000 all together, it has been estimated—a handsome and respectable estate, though by no means a great one. His bequests were mostly straightforward: To his sister he left £20 in cash and the use of the family home on Henley Street for the rest of her life; to each of her three children (including the one whose name he could not recall) he left £5. He also left Joan his clothes. Though clothing had value, it was extremely unusual, according to David Thomas, for it to be left to someone of the opposite sex. Presumably Shakespeare could think of no one else who might welcome it.

The most famous line in the document appears on the third page, where to the original text is added an interlineation, which says, a touch tersely: "I give unto my wife my second-best bed with the furniture" (that is, the bedclothes). The will does not otherwise mention Shakespeare's widow. Scholars have long argued over what can be concluded about their relationship from this.

Beds and bedding were valued objects and often mentioned in wills. It is sometimes argued that the second-best bed was the marital bed—the first bed being reserved for important visitors—and therefore replete with tender associations. But Thomas says the evidence doesn't bear this out and that husbands virtually always gave the best bed to their wives or eldest sons. A second-best bed, he believes, was inescapably a demeaning bequest. It is sometimes pointed out that as a widow Anne would automatically have been entitled to one-third of Shakespeare's estate, and therefore it wasn't necessary for him to single her out for particular bequests. But even allowing for this, it is highly unusual for a spouse to be included so tersely as an afterthought.

A colleague of Thomas's, Jane Cox, now retired, made a study of sixteenth-century wills and found that typically husbands said tender things about their wives—Condell, Heminges, and Augustine Phillips all did—and frequently left them some special remembrance. Shakespeare does neither, but then, as Samuel Schoenbaum notes, he offers "no endearing references to other family members either." With respect to Anne, Thomas suggests that perhaps she was mentally incapacitated. Then again it may be that Shakespeare was simply too ill to include endearments. Thomas thinks it's possible that

Shakespeare's signatures on the will were forged—probably not for any nefarious reason, but simply because he was too ill to wield a quill himself. If the signatures are not genuine, it would be something of a shock to the historical record, as the will contains half of Shakespeare's six known signatures.

He left £10 to the poor of Stratford, which is sometimes suggested as being a touch niggardly, but in fact according to Thomas it was quite generous. A more usual sum for a man of his position was £2. He also left 20 shillings to a godson and small sums to various friends, including (in yet another interlineation) 26 shillings apiece to Heminges, Condell, and Richard Burbage to purchase memorial rings—a common gesture. All the rest went to his two daughters, the bulk to Susanna.

Apart from the second-best bed and the clothes he left to Joan, only two other personal possessions are mentioned—a gilt-and-silver bowl and a ceremonial sword. Judith was given the bowl. The likelihood is that it sits today unrecognized on some suburban sideboard; it was not the sort of object that gets discarded. The sword was left to a local friend, Thomas Combe; its fate is similarly unknown. It is generally assumed that Shakespeare's interests in the Globe and Blackfriars theaters had been sold already, for there is no mention of them. The full inventory of his estate, listing his books and much else of value to history, would have been sent to London, where in all likelihood it perished in the Great Fire of 1666. No trace of it survives.

Shakespeare's wife died in August 1623, just before the publication of the First Folio. His daughter Susanna lived on until

1649, when she died aged sixty-six. His younger daughter, Judith, lived till 1662, and died aged seventy-seven. She had three children, including a son named Shakespeare, but all predeceased her without issue. "Judith was the great lost opportunity," says Stanley Wells. "If any of Shakespeare's early biographers had sought her out, she could have told them all kinds of things that we would now dearly love to know. But no one, it appears, troubled to speak to her." Shakespeare's granddaughter Elizabeth, who equally might have shed light on many Shakespearean mysteries, lived until 1670. She married twice but had no children either, and so with her died the Shakespeare line.

Theaters boomed in the years just after Shakespeare's death, even more so than they had in his lifetime. By 1631, seventeen of them were in operation around London. The good years didn't last long, however. By 1642, when the Puritans shut them down, just six remained—three amphitheaters and three halls. Theaters would never again appeal to so wide a spectrum of society or be such a universal pastime.

Shakespeare's plays might have been lost, too, had it not been for the heroic efforts of his close friends and colleagues John Heminges and Henry Condell, who seven years after his death produced a folio edition of his complete works. It put into print for the first time eighteen of Shakespeare's plays: *Macbeth*; *The Tempest*; *Julius Caesar*; *The Two Gentlemen of Verona*; *Measure for Measure*; *The Comedy of Errors*; *As You Like It*; *The Taming of the Shrew*; *King John*; *All's Well That Ends Well*; *Twelfth Night*; *The Winter's Tale*; *Henry VI, Part 1*; *Henry VIII*;

Coriolanus; *Cymbeline*; *Timon of Athens*; and *Antony and Cleopatra*. Had Heminges and Condell not taken this trouble, the likelihood is that all of these plays would have been lost to us. Now that is true heroism.

Heminges and Condell were the last of the original Chamberlain's Men. As with nearly everyone else in this story, we know only a little about them. Heminges (Kermode makes it *Heminge*; others use *Heming* or *Hemings*) was the company's business manager, but also a sometime actor and, at least according to tradition, is said to have been the first Falstaff—though he is also said to have had a stutter, "an unfortunate handicap for an actor," as Wells notes. He listed himself in his will as a "citizen and grocer of London." A grocer in Shakespeare's day was a trader in bulk items, not someone who sold provisions from a shop (think of *gross*, not *groceries*). In any case the designation meant only that he belonged to the grocers' guild, not that he was actively involved in the trade. He had thirteen children, possibly fourteen, by his wife, Rebecca, widow of the actor William Knell, whose murder at Thame in 1587, it may be recalled, left a vacancy among the Queen's Men into which some commentators have been eager to place a young William Shakespeare.

Condell (or sometimes *Cundell*, as on his will) was an actor, esteemed evidently for comedic roles. Like Shakespeare he invested wisely and was sufficiently wealthy to style himself "gentleman" without fear of contradiction and to own a country home in what was then the outlying village of Fulham. He left Heminges a generous £5 in his will—considerably more than

Shakespeare left Heminges, Condell, and Burbage together in his. Condell had nine children. He and Heminges lived as neighbors in Saint Mary Aldermanbury, within the City walls, for thirty-two years.

After Shakespeare's death they set to putting together the complete works—a matter of no small toil. They must have been influenced by the example of Ben Jonson, who in the year of Shakespeare's death, 1616, had issued a handsome folio of his own work—a decidedly vain and daring thing to do since plays were not normally considered worthy of such grand commemoration. Jonson rather pugnaciously styled the book his "Workes," prompting one waggish observer to wonder if he had lost the ability to distinguish between work and play.

We have no idea how long Heminges and Condell's project took, but Shakespeare had been dead for seven years by the time the volume was ready for publication in the autumn of 1623. It was formally called *Mr. William Shakespeare's Comedies, Histories, and Tragedies*, but has been known to the world ever since—well, nearly ever since—as the First Folio.

A folio, from the Latin *folium*, or "leaf," is a book in which each sheet has been folded just once down the middle, creating two leaves or four pages. A folio page is therefore quite large—typically about fifteen inches high. A quarto book is one in which each sheet is folded twice, to create four leaves—hence "quarto"—or eight pages.

The First Folio was published by Edward Blount and the father-and-son team of William and Isaac Jaggard—a curious choice, since the senior Jaggard had earlier published the book

of poems *The Passionate Pilgrim*, which the title page ascribed to William Shakespeare, though in fact Shakespeare's only contribution was a pair of sonnets and three poems lifted whole from *Love's Labour's Lost*, suggesting that the entire enterprise may have been unauthorized and thus potentially irksome to Shakespeare. At all events, by the time of the First Folio, William Jaggard was so ill that he almost certainly didn't participate in the printing.

Publication was not a decision to be taken lightly. Folios were big books and expensive to produce, so the First Folio was very ambitiously priced at £1 (for an edition bound in calfskin; unbound copies were a little cheaper). A copy of the sonnets, by comparison, cost just 5 pence on publication—or one forty-eighth the price of a folio. Even so the First Folio did well and was followed by second, third, and fourth editions in 1632, 1663–1664, and 1685.

The idea of the First Folio was not just to publish plays that had not before been seen in print but to correct and restore those that had appeared in corrupt or careless versions. Heminges and Condell had the great advantage that they had worked with Shakespeare throughout his career and could hardly have been more intimately acquainted with his work. To aid recollection they had much valuable material to work with—promptbooks, foul papers (as rough drafts or original copies were known) in Shakespeare's own hand, and the company's own fair copies—all now lost.

Before the First Folio all that existed of Shakespeare's plays were cheap quarto editions of exceedingly variable qual-

ity—twelve of them traditionally deemed to be "good" and nine deemed "bad." Good quartos are clearly based on at least reasonably faithful copies of plays; bad ones are generally presumed to be "memorial reconstructions"—that is, versions set down from memory (often very bad memory, it seems) by fellow actors or scribes employed to attend a play and create as good a transcription as they could manage. Bad quartos could be jarring indeed. Here is a sample of Hamlet's soliloquy as rendered by a bad quarto:

> *To be, or not to be, I there's the point,*
> *To Die, to sleepe, is that all? I all.:*
> *No, to sleepe, to dreame, I mary there it goes,*
> *For in that dreame of death, when wee awake,*
> *And borne before an everlasting Judge,*
> *From whence no passenger ever returned. . .*

Heminges and Condell proudly consigned to the scrap heap all these bad versions—the "diverse stolne, and surreptitious copies, maimed, and deformed by the frauds and stealthes of injurious impostors," as they put it in their introduction to the volume—and diligently restored Shakespeare's plays to their "True Originall" condition. The plays were now, in their curious phrase, "cur'd, and perfect of their limbes"—or so they boasted. In fact, however, the First Folio was a decidedly erratic piece of work.

Even to an inexpert eye its typographical curiosities are striking. Stray words appear in odd places—a large and eminently

superfluous "THE" stands near the bottom of page 38, for instance—page numbering is wildly inconsistent, and there are many notable misprints. In one section, pages 81 and 82 appear twice, but pages 77–78, 101–108, and 157–256 don't appear at all. In *Much Ado About Nothing* the lines of Dogberry and Verges abruptly cease being prefixed by the characters' names and instead become prefixed by "Will" and "Richard," the names of the actors who took the parts in the original production—an understandable lapse at the time of performance but hardly an indication of tight editorial control when the play was reprinted years later.

The plays are sometimes divided into acts and scenes but sometimes not; in *Hamlet* the practice of scene division is abandoned halfway through. Character lists are sometimes at the front of plays, sometimes at the back, and sometimes missing altogether. Stage directions are sometimes comprehensive and at other times almost entirely absent. A crucial line of dialogue in *King Lear* is preceded by the abbreviated character name "Cor.," but it is impossible to know whether "Cor." refers to Cornwall or Cordelia. Either one works, but each gives a different shading to the play. The issue has troubled directors ever since.

But these are, it must be said, the most trifling of bleats when we consider where we would otherwise be. "Without the *Folio*," Anthony James West has written, "Shakespeare's history plays would have lacked their beginning and their end, his only Roman play would have been *Titus Andronicus*, and there would have been three, not four, 'great tragedies.' Shorn of these eighteen plays, Shakespeare would not have been the pre-eminent dramatist that he is now."

Heminges and Condell are unquestionably the greatest literary heroes of all time. It really does bear repeating: only about 230 plays survive from the period of Shakespeare's life, of which the First Folio represents some 15 percent, so Heminges and Condell saved for the world not only half the plays of William Shakespeare, but an appreciable portion of *all* Elizabethan and Jacobean drama.

The plays are categorized as Comedies, Histories, and Tragedies. *The Tempest*, one of Shakespeare's last works, is presented first, probably because of its relative newness. *Timon of Athens* is an unfinished draft (or a finished play that suffers from "extraordinary incoherencies," in the words of Stanley Wells). *Pericles* doesn't appear at all—and wouldn't be included in a folio edition for another forty years, possibly because it was a collaboration. For the same reason, probably, Heminges and Condell excluded *The Two Noble Kinsmen* and *The True History of Cardenio*; this is more than a little unfortunate because the latter is now lost.

They *nearly* left out *Troilus and Cressida*, but then at the last minute stuck it in. No one knows what exactly provoked the dithering. They unsentimentally tidied up the titles of the history plays, burdening them with dully descriptive labels that robbed them of their romance. In Shakespeare's day there was no *Henry VI, Part 2*, but rather *The First Part of the Contention Betwixt the Two Famous Houses of York and Lancaster*, while *Henry VI, Part 3* was *The True Tragedy of Richard Duke of York and the Good King Henry the Sixth*—"more interesting, more informative, more grandiloquent," in the words of Gary Taylor.

Despite the various quirks and inconsistencies, and to their eternal credit, Heminges and Condell really did take the trouble, at least much of the time, to produce the most complete and accurate versions they could. *Richard II*, for instance, was printed mostly from a reliable quarto, but with an additional 151 good lines carefully salvaged from other, poorer quarto editions and a promptbook, and much the same kind of care was taken with others in the volume.

"On some texts they went to huge trouble," says Stanley Wells. "*Troilus and Cressida* averages eighteen changes per page—an enormous number. On other texts they were much less discriminating."

Why they were so inconsistent—fastidious here, casual there—is yet another question no one can answer. Why Shakespeare didn't have the plays published in his lifetime is a question not easily answered either. It is often pointed out that in his time a playwright's work belonged to the company, not to the playwright, and therefore was not the latter's to exploit. That is indubitably so, but Shakespeare's close relationships with his fellows surely would have ensured that his wishes would be met had he desired to leave a faithful record of his work, particularly when so much of it existed only in spurious editions. Yet nothing we possess indicates that Shakespeare took any particular interest in his work once it was performed.

This is puzzling because there is reason to believe (or at least to suspect) that some of his plays may have been written to be read as well as performed. Four in particular—*Hamlet*, *Troilus and Cressida*, *Richard III*, and *Coriolanus*—were unnatu-

rally long at 3,200 lines or more, and were probably seldom if ever performed at those lengths. The suspicion is that the extra text was left as a kind of bonus for those with greater leisure to take it in at home. Shakespeare's contemporary John Webster, in a preface to his *The Duchess of Malfi*, noted that he had left in much original, unperformed material for the benefit of his reading public. Perhaps Shakespeare was doing likewise.

It is not quite true that the First Folio is the definitive version for each text. Some quartos, including bad ones, may incorporate later improvements and refinements, or, more rarely, may offer readable text where the Folio version is doubtful or vague. Even the poorest quarto can provide a useful basis of comparison between varying versions of the same text. G. Blakemore Evans cites a line from *King Lear* that is rendered in different early editions of the play as "My Foole usurps my body," "My foote usurps my body," and "My foote usurps my head" (and in fact really makes sense only as "A fool usurps my bed"). Quartos also tend to incorporate more generous stage directions, which can be very helpful to scholars and directors alike.

Sometimes there are such differences between quarto and folio editions of plays that it is impossible to know how to resolve them or to guess which version Shakespeare might ultimately have favored. The most notorious example of this is *Hamlet*, which exists in three versions: a "bad" 1603 quarto of 2,200 lines, a much better 1604 quarto of 3,800 lines, and the 1623 folio version of 3,570 lines. There are reasons to believe that of the three the "bad" first quarto may actually most closely

represent the play as performed. It is certainly brisker than the other versions. Moreover, as Ann Thompson of King's College in London points out, it places Hamlet's famous soliloquy in a different, better place, where suicidal musing seems more apt and rational.

Even more comprehensively problematic is *King Lear*, for which the quarto edition has three hundred lines and an entire scene not found in the First Folio, while the latter has one hundred or so lines not found in the quarto. The two versions assign speeches to different characters, altering the nature of three central roles—Albany, Edgar, and Kent—and the quarto offers a materially different ending. Such are the differences that the editors of the *Oxford Shakespeare* included both versions in the complete works on the grounds that they are not so much two versions of the same play as two different plays. *Othello* likewise differs in more than one hundred lines between quarto and First Folio, but, even more important, has hundreds of different words in the two versions, suggesting extensive later revision.

Nobody knows how many First Folios were printed. Most estimates put the number at about a thousand, but this is really just a guess. Peter W. M. Blayney, the preeminent authority on the First Folio, thinks it was rather less than a thousand. "The fact that the book was reprinted after only nine years," Blayney has written, "suggests a relatively small edition—probably no more than 750 copies, and perhaps fewer." Of these, all or part of three hundred First Folios survive—an extraordinary proportion.

The great repository of First Folios today is a modest building on a pleasant street a couple of blocks from the Capitol in Washington, D.C.—the Folger Shakespeare Library. It is named for Henry Clay Folger, who was president of Standard Oil (and, more distantly, a member of the Folgers coffee family), and who began collecting First Folios early in the twentieth century, when they could often be snapped up comparatively cheaply from hard-up aristocrats and struggling institutions.

As sometimes happens with serious collectors, Folger became increasingly expansive as time went on, and began collecting works not just by or about Shakespeare, but by or about people who liked Shakespeare, so that the collection includes not only much priceless Shakespearean material but also some unexpected curiosities: a manuscript by Thomas de Quincey on how to make porridge, for instance. Folger didn't live to see the library that bears his name. Two weeks after laying the foundation stone in 1930, he died of a sudden heart attack.

The collection today consists of 350,000 books and other items, but the core is the First Folios. The Folger owns more of them than any other institution in the world—though surprisingly, no one can say exactly how many.

"It is not actually easy to say what is a First Folio and what isn't, because most Folios are no longer entirely original and few are entirely complete," Georgianna Ziegler, one of the curators, told me when I visited in the summer of 2005. "Beginning in the late eighteenth century it became common practice to fill out incomplete or broken volumes by inserting pages taken from other volumes, sometimes to quite a radical extent.

Copy sixty-six of our collection is roughly 60 percent cannibal-ized from other volumes. Three of our 'fragment' First Folios are actually more complete than that."

"What we normally say," added her colleague Rachel Doggett, "is that we have approximately one-third of the sur-viving First Folios."

It is customarily written that the Folger has seventy-nine complete First Folios and parts of several others, though in fact only thirteen of the seventy-nine "complete" copies really are complete. Peter Blayney, however, believes the Folger can rea-sonably claim to possess eighty-two complete copies. It really is largely a matter of semantics.

Ziegler and Doggett took me to a secure windowless base-ment room where the rarest and most important of the volumes in the Folger collections are kept. The room was chilly, brightly lit, and rather antiseptic. Had I been blindfolded I might have guessed that it was a room where autopsies were conducted. Instead it was filled with rows of modern shelving containing a vast quantity of very old books. The First Folios lay on their sides on twelve shallow shelves along the back wall. Each book is about eighteen by fourteen inches, roughly the size of an *En-cyclopædia Britannica* volume.

It is worth devoting a moment to considering how books were put together in the early days of movable type. Think of a standard greeting card in which one sheet of paper card is folded in half to make four separate surfaces—front, inside left, inside right, and back. Slip two more folded cards into the first and you have a booklet of twelve pages, or what is known as a

quire—roughly half the length of a play or about the amount of text that a printing workshop would work on at any time. The complication from the printer's point of view is that in order to have the pages run consecutively when slotted together, they must be printed mostly out of sequence. The outer sheet of a quire, for instance, will have pages 1 and 2 on the left-hand leaf but pages 11 and 12 on the right-hand side. Only the innermost two pages of a quire (pages 6 and 7) will actually appear and be printed consecutively. All the others have at least one nonsequential page for a neighbor.

What this meant in producing a book was that it was necessary to work out in advance which text would appear on each of twelve pages. The process was known as casting off, and when it went wrong, as it commonly did, compositors had to make adjustments to get their lines and pages to end in the right places. Sometimes it was a matter of introducing a contraction here and there—using "ye" instead of "the," for example—but sometimes more desperate expedients became necessary. On occasion whole lines were dropped.

With the First Folio, production was spread among three different shops, each employing teams of compositors of varying deftness, experience, and commitment, which naturally resulted in differences from one volume to another. If an error was noticed when a page was being printed, as often happened, it would be corrected at that point in the run. A series of corrections would therefore introduce a number of discrepancies between almost any two volumes. Printers in Shakespeare's day (and, come to that, long after) were notoriously headstrong and

opinionated, and rarely hesitated to introduce improvements as they saw fit. It is known from extant manuscripts that when the publisher Richard Field published a volume by the poet John Harrington, his compositors introduced more than a thousand changes to the spelling and phrasing.

In addition to all the intentional alterations made during the course of production, there were many minute differences in wear and quality between different pieces of type, especially if taken from different typecases. Realizing all this, in the 1950s Charlton Hinman made a microscopic examination of fifty-five Folger folios using a special magnifier that he built himself. The result was *The Printing and Proof-Reading of the First Folio of Shakespeare* (1963), one of the most extraordinary pieces of literary detection of the last century.

By carefully studying and collating individual printers' preferences as well as microscopic flaws on certain letters through each of the fifty-five volumes, Hinman was able to work out which compositors did which work. Eventually he identified nine separate hands—whom he labeled A, B, C, D, and so on—at work on the First Folio.

Although nine hands contributed, their workload was decidedly unequal; B alone was responsible for nearly half the published text. By chance one of the compositors may have been a John Shakespeare, who trained with Jaggard the previous decade. If so, his connection to the enterprise was entirely coincidental; he had no known relationship to William Shakespeare. Ironically the compositor whose identity can most confidently be surmised—a young man from Hursley in

Hampshire named John Leason, who was known to Hinman as Hand E—was the worst by far. He was the apprentice—and not a very promising one, it would appear from the quality of his work.

Among much else Hinman determined that no two volumes of the First Folio were exactly the same. "The idea that every single volume would be different from every other was unexpected, and obviously you would need a lot of volumes to make that determination," said Rachel Doggett with a look of real satisfaction. "So Folger's obsession with collecting Folios turned out to be quite a valuable thing for scholarship."

"What is slightly surprising," Ziegler said, "is that all the fuss is about a book that wasn't actually very well made." To demonstrate her point she laid open on a table one of the First Folios and placed beside it a copy of Ben Jonson's own complete works. The difference in quality was striking. In the Shakespeare First Folio, the inking was conspicuously poor; many passages were faint or very slightly smeared.

"The paper is handmade," she added, "but of no more than middling quality." Jonson's book in comparison was a model of stylish care. It was beautifully laid out, with decorative drop capitals and printer's ornaments, and it incorporated many useful details such as the dates of first performances, which were lacking from the Shakespeare volume.

At the time of Shakespeare's death few would have supposed that one day he would be thought the greatest of English playwrights. Francis Beaumont, John Fletcher, and Ben Jonson

were all more popular and esteemed. The First Folio contained just four poetic eulogies—a starkly modest number. When the now obscure William Cartwright died in 1643, five dozen admirers jostled to offer memorial poems. "Such are the vagaries of reputation," sighs Schoenbaum in his *Documentary Life*.

This shouldn't come entirely as a surprise. Ages are generally pretty incompetent at judging their own worth. How many people now would vote to bestow Nobel Prizes for Literature on Pearl Buck, Henrik Pontoppidan, Rudolf Eucken, Selma Lagerlöf, or many others whose fame could barely make it to the end of their own century?

In any case Shakespeare didn't altogether delight Restoration sensibilities, and his plays were heavily adapted when they were performed at all. Just four decades after his death, Samuel Pepys thought *Romeo and Juliet* "the worst that ever I heard in my life"—until, that is, he saw *A Midsummer Night's Dream*, which he thought "the most insipid ridiculous play that ever I saw in my life." Most observers were more admiring than that, but on the whole they preferred the intricate plotting and thrilling twists of Beaumont and Fletcher's *Maid's Tragedy*, *A King and No King*, and others that are now largely forgotten except by scholars.

Shakespeare never entirely dropped out of esteem—as the publication of Second, Third, and Fourth Folios clearly attests—but neither was he reverenced as he is today. After his death some of his plays weren't performed again for a very long time. *As You Like It* was not revived until the eighteenth century. *Troilus and Cressida* had to wait until 1898 to be staged again,

in Germany, though John Dryden in the meanwhile helpfully gave the world a completely reworked version. Dryden took this step because, he explained, much of Shakespeare was ungrammatical, some of it coarse, and the whole of it "so pester'd with Figurative expressions, that it is as affected as it is obscure." Nearly everyone agreed that Dryden's version, subtitled "Truth Found Too Late," was a vast improvement. "You found it dirt but you have made it gold," gushed the poet Richard Duke.

The poems, too, went out of fashion. The sonnets "were pretty well forgotten for over a century and a half," according to W. H. Auden, and *Venus and Adonis* and *The Rape of Lucrece* were likewise overlooked until rediscovered by Samuel Taylor Coleridge and his fellow Romantics in the early 1800s.

Such was Shakespeare's faltering status that as time passed the world began to lose track of what exactly he had written. The Third Folio, published forty years after the first, included six plays that Shakespeare didn't in fact write—*A Yorkshire Tragedy*, *The London Prodigal*, *Locrine*, *Sir John Oldcastle*, *Thomas Lord Cromwell*, and *The Puritan Widow*—though it did finally make room for *Pericles*, for which scholars and theatergoers have been grateful ever since. Other collections of his plays contained still other works—*The Merry Devil of Edmonton*, *Mucedorus*, *Iphis and Ianthe*, and *The Birth of Merlin*. It would take nearly two hundred years to resolve the problem of authorship generally, and in detail it isn't settled yet.

Almost a century elapsed between William Shakespeare's death and the first even slight attempts at biography, by which time much detail of his life was gone for good. The first stab at

a life story came in 1709, when Nicholas Rowe, Britain's poet laureate and a dramatist in his own right, provided a forty-page background sketch as part of the introduction to a new six-volume set of Shakespeare's complete works. Most of it was drawn from legend and hearsay, and a very large part of that was incorrect. Rowe gave Shakespeare three daughters rather than two, and credited him with the authorship of a single long poem, *Venus and Adonis*, apparently knowing nothing of *The Rape of Lucrece*. It is to Rowe that we are indebted for the attractive but specious story of Shakespeare's having been caught poaching deer at Charlecote. According to the later scholar Edmond Malone, of the eleven facts asserted about Shakespeare's life by Rowe, eight were incorrect.

Nor was Shakespeare always terribly well served by those who strove to restore his reputation. The poet Alexander Pope, extending the tradition begun by Dryden, produced a handsome set of Shakespeare's works in 1723, but freely reworked any material he didn't like, which was a good deal of it. He discarded passages he thought unworthy (insisting that they were the creations of actors, not Shakespeare himself), replaced archaic words that he didn't understand with modern words he did, threw out nearly all puns and other forms of wordplay, and constantly altered phrasing and meter to suit his own unyieldingly discerning tastes. Where, for instance, Shakespeare wrote about taking arms against a sea of troubles, he changed *sea* to *siege* to avoid a mixed metaphor.

Partly in response to Pope's misguided efforts there now poured forth a small flood of new editions and scholarly stud-

ies. Lewis Theobald, Sir Thomas Hanmer, William Warburton, Edward Capell, George Steevens, and Samuel Johnson produced separate contributions that collectively did much to revitalize Shakespeare's standing.

Even more influential was the actor-manager David Garrick, who in the 1740s began a long, adoring, and profitable relationship with Shakespeare's works. Garrick's productions were not without their idiosyncrasies. He gave *King Lear* a happy ending and had no hesitation in dropping three of the five acts of *The Winter's Tale* to keep the narrative moving briskly if not altogether coherently. Despite these quirks Garrick set Shakespeare on a trajectory that shows no sign of encountering a downward arc yet. More than any other person, he put Stratford on the tourist map—a fact of very considerable annoyance to the Reverend Francis Gastrell, a vicar who owned New Place and who grew so weary of the noisy intrusions of tourists that in 1759 he tore the house down rather than suffer another unwelcome face at the window.

(At least the birthplace escaped the fate considered for it by the impresario P. T. Barnum, who in the 1840s had the idea of shipping it to the United States, placing it on wheels, and sending it on a perpetual tour around the country—a prospect so alarming that money was swiftly raised in Britain to save the house as a museum and shrine.)

Critical appreciation of Shakespeare may be said to begin with William Dodd, who was both a clergyman and a scholar of the first rank—his *Beauties of Shakespeare* (1752) remained hugely

influential for a century and a half—but something of a rogue as well. In the early 1770s, he fell into debt and fraudulently acquired £4,200 by forging the signature of Lord Chesterfield on a bond. For his efforts he was sent to the scaffold—inaugurating a long tradition of Shakespeare scholars being at least a little eccentric, if not actively wayward.

Real Shakespeare scholarship starts with Edmond Malone. Malone, who was Irish and a barrister by training, was in many ways a great scholar though always a slightly worrying one. In 1763, while still in his early twenties, Malone moved to London, where he developed an interest in everything to do with Shakespeare's life and works. He became a friend of James Boswell's and Samuel Johnson's, and ingratiated himself with all the people with the most useful records. The master of Dulwich College lent him the collected papers of Philip Henslowe and Edward Alleyn. The vicar of Stratford-upon-Avon allowed him to borrow the parish registers. George Steevens, another Shakespeare scholar, was so taken with Malone that he gave him his entire collection of old plays. Soon afterward, however, the two had a bitter falling-out, and for the rest of his career Steevens wrote little that didn't contain, in the words of the *Dictionary of National Biography*, "many offensive references to Malone."

Malone made some invaluable contributions to Shakespeare scholarship. Before he came on the scene, nobody knew much of anything about William Shakespeare's immediate family. Part of the problem was that Stratford in the 1580s and 1590s was home to a second, unrelated John Shakespeare,

a shoemaker who married twice and had at least three children. Malone painstakingly worked out which Shakespeares belonged to which families—an endeavor of everlasting value to scholarship—and made many other worthwhile corrections concerning the details of Shakespeare's life.

Flushed with enthusiasm for his ingenious detective work, Malone became resolved to settle an even trickier issue, and devoted years to producing *An Attempt to Ascertain the Order in Which the Plays of Shakespeare Were Written*. Unfortunately the book was completely wrong and deeply misguided. For some reason Malone decided that Heminges and Condell were not to be trusted, and he began to subtract plays from the Shakespearean canon—notably *Titus Adronicus* and the three parts of *Henry VI*—on the grounds that they were not very good and he didn't like them. It was at about this time that he persuaded the church authorities at Stratford to whitewash the memorial bust of William Shakespeare in Holy Trinity, removing virtually all its useful detail, in the mistaken belief that it had not originally been painted.

Meanwhile the authorities at both Stratford and Dulwich were becoming increasingly restive at Malone's strange reluctance to give back the documents he had borrowed. The vicar at Stratford had actually to threaten him with a lawsuit to gain the return of his parish registers. The Dulwich authorities didn't need to go so far, but were appalled to discover, when their documents arrived back, that Malone had scissored parts of them out to retain as keepsakes. "It is clear," wrote R. A. Foakes, "that several excisions have been made for the sake of

the signatures on them of well-known dramatists"—an act of breathtaking vandalism that did nothing for scholarship or Malone's reputation.

Yet Malone, remarkably, was a model of restraint compared with others, such as John Payne Collier, who was also a scholar of great gifts, but grew so frustrated at the difficulty of finding physical evidence concerning Shakespeare's life that he began to create his own, forging documents to bolster his arguments if not, ultimately, his reputation. He was eventually exposed when the keeper of mineralogy at the British Museum proved with a series of ingenious chemical tests that several of Collier's "discoveries" had been written in pencil and then traced over and that the ink in the forged passages was demonstrably not ancient. It was essentially the birth of forensic science. This was in 1859.

Even worse in his way was James Orchard Halliwell (later Halliwell-Phillipps), who was a dazzling prodigy—he was elected a fellow of both the Royal Society and the Society of Antiquaries while still a teenager—but also a terrific thief. Among his crimes were stealing seventeen rare volumes of manuscripts from the Trinity College Library at Cambridge (though it must be said that he was never convicted of it) and defacing literally hundreds of books, including a quarto edition of *Hamlet*—one of only two in existence. After his death, among his papers were found 3,600 pages or parts of pages torn from some eight hundred early printed books and manuscripts, many of them irreplaceable—a most exceptional act of destruction. On the plus side he wrote the definitive life of

Shakespeare in the nineteenth century and much else besides. In fairness it must be noted again that Halliwell was merely accused, but never convicted, of theft, but there was certainly a curious long-standing correspondence between a Halliwell visit to a library and books going missing.

After his death William Shakespeare was laid to rest in the chancel of Holy Trinity, a large, lovely church beside the Avon. As we might by now expect, his life concludes with a mystery—indeed, with a small series of them. His gravestone bears no name, but merely a curious piece of doggerel:

> *Good friend, for Jesus' sake forbeare,*
> *To digg the dust encloased heare.*
> *Bleste be the man that spares thes stones*
> *And curst be he that moves my bones.*

His grave is placed with those of his wife and members of his family, but as Stanley Wells points out, there is a distinct oddness in the order in which they lie. Reading from left to right, the years of deaths of the respective occupants are 1623, 1616, 1647, 1635, and 1649—hardly a logical sequence. They also represent an odd grouping in respect of their relationships. Shakespeare lies between his wife and Thomas Nash, husband of his granddaughter Elizabeth, who died thirty-one years after him. Then come his son-in-law John Hall and daughter Susanna. Shakespeare's parents, siblings, and twin children were no doubt buried in the churchyard and are excluded. The

group is rounded out by two other graves, for Francis Watts and Anne Watts; they have no known Shakespeare connection, though who exactly they were is a matter that awaits scholarly inquiry. Also for reasons unknown, Shakespeare's gravestone is conspicuously shorter—by about eighteen inches—than all the others in the group.

Attached to the north chancel wall overlooking this grouping is the famous life-size painted bust that Edmond Malone ordered whitewashed in the eighteenth century, though it has since been repainted. It shows Shakespeare with a quill and a staring expression and bears the message:

> *Stay, passenger, why goest thou by so fast?*
> *Read, if thou canst, whom envious death hath placed*
> *Within this monument: Shakespeare, with whom*
> *Quick nature died' whose name doth check this tomb*
> *Far more than cost, sith all that he hath writ*
> *Leaves living art but page to serve his wit.*

Since Shakespeare patently has never been within the monument, many have puzzled over what those lines mean. Paul Edmondson has made a particular study of the Shakespeare graves and memorial, but happily agrees that it is more or less impossible to interpret sensibly. "For one thing, it calls itself a tomb even though it is not a tomb at all but a memorial," he says. One suggestion that has many times been made is that the monument contains not the body of Shakespeare but the body of his work: his manuscripts.

"A lot of people ache to believe that the manuscripts still exist somewhere," Edmondson says, "but there is no evidence to suppose that they are in the monument or anywhere else. You just have to accept that they are gone for good."

As for the heroes of this chapter, Henry Condell died four years after the publication of the First Folio, in 1627, and John Heminges followed three years later. They were buried near each other in the historic London church of Saint Mary Aldermanbury. That church was lost in the Great Fire of 1666 and replaced by a Christopher Wren structure, which in turn was lost to German bombs in World War II.

Chapter Nine

Claimants

THERE IS AN EXTRAORDINARY—seemingly an insatiable—urge on the part of quite a number of people to believe that the plays of William Shakespeare were written by someone other than William Shakespeare. The number of published books suggesting—or more often insisting—as much is estimated now to be well over five thousand.

Shakespeare's plays, it is held, so brim with expertise—on law, medicine, statesmanship, court life, military affairs, the bounding main, antiquity, life abroad—that they cannot possibly be the work of a single lightly educated provincial. The presumption is that William Shakespeare of Stratford was, at best, an amiable stooge, an actor who lent his name as cover for someone of greater talent, someone who could not, for one reason or another, be publicly identified as a playwright.

The controversy has been given respectful airings in the highest quarters. PBS, the American television network, in

1996 produced an hour-long documentary unequivocally suggesting that Shakespeare probably wasn't Shakespeare. *Harper's Magazine* and the *New York Times* have both devoted generous amounts of space to sympathetically considering the anti-Stratford arguments. The Smithsonian Institution in 2002 held a seminar titled "Who Wrote Shakespeare?"—a question that most academics would have thought hopelessly tautological. The best-read article in the British magazine *History Today* was one examining the authorship question. Even *Scientific American* entered the fray with an article proposing that the person portrayed in the famous Martin Droeshout engraving might actually be—I weep to say it—Elizabeth I. Perhaps the most extraordinary development of all is that Shakespeare's Globe Theatre in London—built as a monument for his plays and with aspirations to be a world-class study center—became, under the stewardship of the artistic director Mark Rylance, a kind of clearinghouse for anti-Stratford sentiment.

So it needs to be said that nearly all of the anti-Shakespeare sentiment—actually all of it, every bit—involves manipulative scholarship or sweeping misstatements of fact. Shakespeare "never owned a book," a writer for the *New York Times* gravely informed readers in one doubting article in 2002. The statement cannot actually be refuted, for we know nothing about his incidental possessions. But the writer might just as well have suggested that Shakespeare never owned a pair of shoes or pants. For all the evidence tells us, he spent his life naked from the waist down, as well as bookless, but it is probable that what is lacking is the evidence, not the apparel or the books.

Daniel Wright, a professor at Concordia University in Portland, Oregon, and an active anti-Stratfordian, wrote in *Harper's Magazine* that Shakespeare was "a simple, untutored wool and grain merchant" and "a rather ordinary man who had no connection to the literary world." Such statements can only be characterized as wildly imaginative. Similarly, in the normally unimpeachable *History Today*, William D. Rubinstein, a professor at the University of Wales at Aberystwyth, stated in the opening paragraph of his anti-Shakespeare survey: "Of the seventy-five known contemporary documents in which Shakespeare is named, not one concerns his career as an author."

That is not even close to being so. In the Master of the Revels' accounts for 1604–1605—that is, the record of plays performed before the king, about as official a record as a record can be—Shakespeare is named seven times as the author of plays performed before James I. He is identified on the title pages as the author of the sonnets and in the dedications of the poems *The Rape of Lucrece* and *Venus and Adonis*. He is named as author on several quarto editions of his plays, by Francis Meres in *Palladis Tamia*, and (allusively but unmistakably) by Robert Greene in the *Groat's-Worth of Wit*. John Webster identifies him as one of the great playwrights of the age in his preface to *The White Devil*.

The only absence among contemporary records is not of documents connecting Shakespeare to his works but of documents connecting any other human being to them. As the Shakespeare scholar Jonathan Bate has pointed out, virtually no one "in Shakespeare's lifetime or for the first two hundred years after his death expressed the slightest doubt about his authorship."

So where did all the anti-Stratford sentiment come from? The story begins, a little unexpectedly, with an odd and frankly unlikely American woman named Delia Bacon. Bacon was born in 1811 in the frontier country of Ohio into a large family and a small log cabin. The family was poor and became more so after her father died when Delia was young.

Delia was bright and apparently very pretty but not terribly stable. As an adult, she taught school and wrote a little fiction, but mostly she led a life of spinsterly anonymity in New Haven, Connecticut, where she lived with her brother, a minister. The one lively event in her secluded existence came in the 1840s, when she developed a passionate, seemingly obsessive, attachment to a theological student some years her junior. The affair, such as it was, ended in humiliation for her when she discovered that the young man was in the habit of amusing his friends by reading to them passages from her feverishly tender letters. It was a cruelty from which she never recovered.

Gradually, for reasons that are not clear, she became convinced that Francis Bacon, her distinguished namesake, was the true author of the works of William Shakespeare. The idea was not entirely original to Delia Bacon—one Reverend James Wilmot, a provincial rector in Warwickshire, raised questions about Shakespeare's authorship as early as 1785. But his doubts weren't known until 1932, so Delia's conviction was arrived at independently. Though she had no known genealogical connection to Francis Bacon, the correspondence of names was almost certainly more than coincidental.

In 1852 she traveled to England and embarked on a long and

fixated quest to prove William Shakespeare a fraud. It is easy to dismiss Delia as mildly demented and inconsequential, but there was clearly something beguiling in her manner and physical presence, for she succeeded in winning the assistance of a number of influential people (though often, it must be said, they came to regret it). Charles Butler, a wealthy businessman, agreed to fund the costs of her trip to England—and must have done so generously, for she stayed for almost four years. Ralph Waldo Emerson gave her an introduction to Thomas Carlyle, who in turn assisted her upon her arrival in London. Bacon's research methods were singular to say the least. She spent ten months in St. Albans, Francis Bacon's hometown, but claimed not to have spoken to anyone during the whole of that time. She sought no information from museums or archives and politely declined Carlyle's offers of introductions to the leading scholars. Instead she sought out locations where Bacon had spent time and silently "absorbed atmospheres," refining her theories by a kind of intellectual osmosis.

In 1857 she produced her magnum opus, *The Philosophy of the Plays of Shakspere* [*sic*] *Unfolded*, published by Ticknor and Fields of Boston. It was vast, unreadable, and odd in almost every way. For one thing, not once in its 675 densely printed pages did it actually mention Francis Bacon; the reader had to deduce that he was the person whom she had in mind as the author of Shakespeare's plays. Nathaniel Hawthorne, who was at the time American consul in Liverpool, provided a preface, then almost instantly wished he hadn't, for the book was universally regarded by reviewers as preposterous hokum. Hawthorne under questioning admitted that he hadn't actually read it. "This shall be

the last of my benevolent follies, and I will never be kind to anybody again as long as [I] live," he vowed in a letter to a friend.

Exhausted by the strain of her labors, Delia returned to her homeland and retreated into insanity. She died peacefully but unhappily under institutional care in 1859, believing she was the Holy Ghost. Despite the failure of her book and the denseness of its presentation, somehow the idea that Bacon wrote Shakespeare took wing in a very big way. Mark Twain and Henry James became prominent supporters of the Baconian thesis. Many became convinced that the plays of Shakespeare contained secret codes that revealed the true author (who at this stage was always seen to be Bacon).

Using ingenious formulas involving prime numbers, square roots, logarithms, and other arcane devices to guide them, in a kind of Ouija-board fashion, to hidden messages in the text, they found support for the contention. In *The Great Cryptogram*, a popular book of 1888, Ignatius Donnelly, an American lawyer, revealed such messages as this, in *Henry IV, Part 1*: "Seas ill [for which read "Cecil," for William Cecil, Lord Burghley] said that More low or Shak'st Spur never writ a word of them." Admiration for Donnelly's ingenious deciphering methodology faltered somewhat, however, when another amateur cryptographer, the Reverend R. Nicholson, using exactly the same method in the same texts, found such messages as "Master Will-I-am Shak'stspurre writ the Play and was engaged at the Curtain."

No less meticulous in his inventive skills was Sir Edwin Durning-Lawrence, who in another popular book, *Bacon Is Shakespeare*, published in 1910, found telling anagrams sprin-

kled throughout the plays. Most famously he saw that a nonce word used in *Love's Labour's Lost*, "honorificabilitudinitatiubus," could be transformed into the Latin hexameter "Hi ludi F. Baconis nati tuiti orbi," or "These plays, F. Bacon's offspring, are preserved for the world."

It has also been written many times that Stratford never occurs in any Shakespeare play, whereas St. Albans, Bacon's seat, is named seventeen times. (Bacon was Viscount St. Albans.) For the record St. Albans is mentioned fifteen times, not seventeen, and these are in nearly every case references to the Battle of St. Albans—a historical event crucial to the plot of the second and third parts of Henry VI. (The other three references are to the saint himself.) On such evidence one might far more plausibly make Shakespeare a Yorkshireman, since York appears fourteen times more often in his plays than does St. Albans. Even Dorset, a county that plays a central part in none of the plays, gets more mentions.

Eventually Baconian theory took on a cultlike status, with its more avid supporters suggesting that Bacon wrote not only the plays of Shakespeare but also those of Marlowe, Kyd, Greene, and Lyly, as well as Spenser's *Faerie Queene*, Burton's *Anatomy of Melancholy*, Montaigne's *Essays* (in French), and the King James Version of the Bible. Some believed him to be the illegitimate offspring of Queen Elizabeth and her beloved Leicester.

One obvious objection to any Baconian theory is that Bacon had a very full life already without taking on responsibility for the Shakespearean canon as well, never mind the works of Montaigne, Spenser, and the others. There is also an inconve-

nient lack of connection between Bacon and any human being associated with the theater—perhaps not surprisingly, as he appears to have quite disliked the theater and attacked it as a frivolous and lightweight pastime in one of his many essays.

Partly for this reason doubters began to look elsewhere. In 1918 a schoolmaster from Gateshead, in northeast England, with the inescapably noteworthy name of J. Thomas Looney put the finishing touches to his life's work, a book called *Shakespeare Identified*, in which he proved to his own satisfaction that the actual author of Shakespeare was the seventeenth Earl of Oxford, one Edward de Vere. It took him two years to find a publisher willing to publish the book under his own name. Looney steadfastly refused to adopt a pseudonym, arguing, perhaps just a touch desperately, that his name had nothing to do with insanity and was in fact pronounced *loney*. (Interestingly, Looney was not alone in having a mirthful surname. As Samuel Schoenbaum once noted with clear pleasure, other prominent anti-Stratfordians of the time included Sherwood E. Silliman and George M. Battey.)

Looney's argument was built around the conviction that William Shakespeare lacked the worldliness and polish to write his own plays, and that they must therefore have come from someone of broader learning and greater experience: an aristocrat in all likelihood. Oxford, it may be said, had certain things in his favor as a candidate: He was clever and had some standing as a poet and playwright (though none of his plays survives, and none of his poetry indicates actual greatness—certainly not Shakespearean greatness); he was well traveled and spoke Italian, and he moved in the right circles to understand courtly

matters. He was much admired by Queen Elizabeth, who, it was said, "delighteth . . . in his personage and his dancing and valiantness," and one of his daughters was engaged for a time to Southampton, the dedicatee of Shakespeare's two long poems. His connections, without question, were impeccable.

But Oxford also had shortcomings that seem not to sit well with the compassionate, steady, calm, wise voice that speaks so reliably and seductively from Shakespeare's plays. He was arrogant, petulant, and spoiled, irresponsible with money, sexually dissolute, widely disliked, and given to outbursts of deeply unsettling violence. At the age of seventeen, he murdered a household servant in a fury (but escaped punishment after a pliant jury was persuaded to rule that the servant had run onto his sword). Nothing in his behavior, at any point in his life, indicated the least gift for compassion, empathy, or generosity of spirit—or indeed the commitment to hard work that would have allowed him to write more than three dozen plays anonymously, in addition to the work under his own name, while remaining actively engaged at court.

Looney never produced evidence to explain why Oxford—a man of boundless vanity—would seek to hide his identity. Why would he be happy to give the world some unremembered plays and middling poems under his own name, but then retreat into anonymity as he developed, in middle age, a fantastic genius? All Looney would say on the matter was: "That, however, is his business, not ours." Actually, if we are to believe in Oxford, it is entirely our business. It has to be.

The problems with Oxford don't end quite there. There is the matter of the dedications to his two narrative poems. At the time

of *Venus and Adonis*, Oxford was forty-four years old and a senior earl to Southampton, who was still a downy youth. The sycophantic tone of the dedication, with its apology for choosing "so strong a prop for so weak a burden" and its promise to "take advantage of all idle hours till I have honoured you with some graver labour," is hardly the voice one would expect to find from a senior aristocrat, particularly one as proud as Oxford, to a junior one . There is also the unanswered question of why Oxford, patron of his own acting company, the Earl of Oxford's Men, would write his best work for the Lord Chamberlain's Men, a competing troupe. Then, too, there is the problem of explaining away the many textual references that point to William Shakespeare's authorship—the pun on Anne Hathaway's name in the sonnets, for example. Oxford was a sophisticated dissembler indeed if he embedded punning references to the wife of his front man in his work.

But easily the most troubling weakness of the Oxford argument is that Edward de Vere incontestably died in 1604, when many of Shakespeare's plays had not yet appeared—indeed in some cases could not have been written, as they were influenced by later events. *The Tempest*, notably, was inspired by an account of a shipwreck on Bermuda written by one William Strachey in 1609. *Macbeth* likewise was clearly cognizant of the Gunpowder Plot, an event Oxford did not live to see.

Oxfordians, of whom there remain many, argue that de Vere either must have left a stack of manuscripts, which were released at measured intervals under William Shakespeare's name, or that the plays have been misdated and actually appeared before Oxford sputtered his last. As for any references within the plays

that unquestionably postdate Oxford's demise, those were doubtless added later by other hands. They *must* have been, or else we would have to conclude that Oxford didn't write the plays.

Despite the manifest shortcomings of Looney's book, in both argument and scholarship, it found a curious measure of support. The British Nobel laureate John Galsworthy praised it, as did Sigmund Freud (though Freud later came to have a private theory that Shakespeare was of French stock and was really named Jacques Pierre—an interesting but ultimately solitary delusion). In America a Professor L. P. Bénézet of Dartmouth College became a leading Oxfordian. He it was who propounded the theory that Shakespeare the actor was de Vere's illegitimate son. Orson Welles became a fan of the notion, and later supporters include the actor Derek Jacobi.

A third—and for a brief time comparatively popular—candidate for Shakespearean authorship was Christopher Marlowe. He was the right age (just two months older than Shakespeare), had the requisite talent, and would certainly have had ample leisure after 1593, assuming he wasn't too dead to work. The idea is that Marlowe's death was faked, and that he spent the next twenty years hidden away either in Kent or Italy, depending on which version you follow, but in either case under the protection of his patron and possible lover Thomas Walsingham, during which time he cranked out most of Shakespeare's oeuvre.

The champion of this argument was a New York press agent named Calvin Hoffman, who in 1956 secured permission to open Walsingham's tomb, hoping to find manuscripts and letters that would prove his case. In fact, he found nothing at

all—not even Walsingham, who, it turns out, was buried else-where. Still, he got a best-selling book out of it, *The Murder of the Man Who Was "Shakespeare,"* which the *Times Literary Supplement* memorably dismissed as "a tissue of twaddle." Much of Hoffman's case had, it must be said, a kind of loopy charm. Among quite a lot else, he claimed that the "Mr W.H." noted on the title page of the sonnets was "Mr Walsing-Ham." Despite the manifest feebleness of Hoffman's case, and the fact that its support has withered to almost nothing, in 2002 the dean and chapter of Westminster Abbey took the extraordinary step of placing a question mark behind the year of Marlowe's death on a new monument to him in Poets' Corner.

And still the list of alternative Shakespeares rolls on. Yet another candidate was Mary Sidney, Countess of Pembroke. The proponents of this view—a small group, it must be said—maintain that this explains why the First Folio was dedicated to the earls of Pembroke and Montgomery: They were her sons. The countess, it is also noted, had estates on the Avon and her private crest bore a swan—hence Ben Jonson's reference to "sweet swan of Avon." Mary Sidney certainly makes an appealing candidate. She was beautiful as well as learned and well connected: Her uncle was Robert Dudley, the Earl of Leicester, and her brother the poet and patron of poets Sir Philip Sidney. She spent much of her life around people of a literary bent, most notably Edmund Spenser, who dedicated one of his poems to her. All that is missing to connect her with Shakespeare is anything to connect her with Shakespeare.

Yet another theory holds that Shakespeare was too brilliant

to be a single person, but was actually a syndicate of stellar talents, including nearly all of those mentioned already—Bacon, the Countess of Pembroke, and Sir Philip Sidney, plus Sir Walter Raleigh and some others. Unfortunately the theory not only lacks evidence but would involve a conspiracy of silence of improbable proportions.

Finally, a word should be said for Dr. Arthur Titherley, a dean of science at the University of Liverpool, who devoted thirty years of spare-time research to determining (to virtually no one's satisfaction but his own) that Shakespeare was William Stanley, sixth Earl of Derby. All together, more than fifty candidates have been suggested as possible alternative Shakespeares.

The one thing all the competing theories have in common is the conviction that William Shakespeare was in some way unsatisfactory as an author of brilliant plays. This is really quite odd. Shakespeare's upbringing, as I hope this book has shown, was not backward or in any way conspicuously deprived. His father was the mayor of a consequential town. In any case, it would hardly be a unique achievement for someone brought up modestly to excel later in life. Shakespeare lacked a university education, to be sure, but then so did Ben Jonson—a far more intellectual playwright—and no one ever suggests that Jonson was a fraud.

It is true that William Shakespeare used some learned parlance in his work, but he also employed imagery that clearly and ringingly reflected a rural background. Jonathan Bate quotes a couplet from *Cymbeline*, "Golden lads and girls all must, / As chimney sweepers, come to dust," which takes on additional sense when one realizes that in Warwickshire in

the sixteenth century a flowering dandelion was a golden lad, while one about to disperse its seeds was a chimney sweeper. Who was more likely to employ such terms—a courtier of privileged upbringing or someone who had grown up in the country? Similarly, when Falstaff notes that as a boy he was small enough to creep "into any alderman's thumb-ring" we might reasonably wonder whether such a singular image was more likely to occur to an aristocrat or someone whose father actually was an alderman.

In fact a Stratford boyhood lurks in all the texts. For a start Shakespeare knew animal hides and their uses inside and out. His work contains frequent knowing references to arcana of the tanning trade: skin bowgets, greasy fells, neat's oil, and the like—matters of everyday conversation to leather workers, but hardly common currency among the well-to-do. He knew that lute strings were made of cowgut and bowstrings of horsehair. Would Oxford or any other candidate have been able, or likely, to turn such distinctions into poetry?

Shakespeare was, it would seem, unashamedly a country boy, and nothing in his work suggests any desire, in the words of Stephen Greenblatt, to "repudiate it or pass himself off as something other than he was." Part of the reason Shakespeare was mocked by the likes of Robert Greene was that he never stopped using these provincialisms. They made him mirthful in their eyes.

A curious quirk of Shakespeare's is that he very seldom used the word *also*. It appears just thirty-six times in all his plays, nearly always in the mouths of comical characters whose pretentious utterings are designed to amuse. It was an odd preju-

dice and one not shared by any other writer of his age. Bacon sometimes used *also* as many times on a single page as Shakespeare did in the whole of his career. Just once in all his plays did Shakespeare use *mought* as an alternative to *might*. Others used it routinely. Generally he used *hath*, but about 20 percent of the time he used *has*. On the whole he wrote *doth*, but about one time in four he wrote *dost* and more rarely he favored the racily modern *does*. Overwhelmingly he used *brethren*, but just occasionally (about one time in eight) he used *brothers*.

Such distinguishing habits constitute what is known as a person's idiolect, and Shakespeare's, as one would expect, is unlike any other person's. It is not impossible that Oxford or Bacon might have employed such particular distinctions when writing under an assumed identity, but it is reasonable to wonder whether either would have felt such fastidious camouflage necessary.

In short it is possible, with a kind of selective squinting, to endow the alternative claimants with the necessary time, talent, and motive for anonymity to write the plays of William Shakespeare. But what no one has ever produced is the tiniest particle of evidence to suggest that they actually did so. These people must have been incredibly gifted—to create, in their spare time, the greatest literature ever produced in English, in a voice patently not their own, in a manner so cunning that they fooled virtually everyone during their own lifetimes and for four hundred years afterward. The Earl of Oxford, better still, additionally anticipated his own death and left a stock of work sufficient to keep the supply of new plays flowing at the same rate until Shakespeare himself was ready to die a decade or so later. Now that *is* genius!

If it was a conspiracy, it was a truly extraordinary one. It would have required the cooperation of Jonson, Heminges, and Condell and most or all of the other members of Shakespeare's company, as well as an unknowable number of friends and family members. Ben Jonson kept the secret even in his private notebooks. "I remember," he wrote there, "the players have often mentioned it as an honour to Shakespeare, that in his writing (whatsoever he penned) he never blotted out a line. My answer hath been, would he had blotted a thousand." Rather a strange thing to say in a reminiscence written more than a dozen years after the subject's death if he knew that Shakespeare didn't write the plays. It was in the same passage that he wrote, "For I loved the man, and do honour his memory (on this side idolatry) as much as any."

And that's just on Shakespeare's side of the deception. No acquaintance of Oxford's or Marlowe's or Bacon's let slip either, as far as history can tell. One really must salute the ingenuity of the anti-Stratfordian enthusiasts who, if they are right, have managed to uncover the greatest literary fraud in history, without the benefit of anything that could reasonably be called evidence, four hundred years after it was perpetrated.

When we reflect upon the works of William Shakespeare it is of course an amazement to consider that one man could have produced such a sumptuous, wise, varied, thrilling, ever-delighting body of work, but that is of course the hallmark of genius. Only one man had the circumstances and gifts to give us such incomparable works, and William Shakespeare of Stratford was unquestionably that man—whoever he was.

Selected Bibliography

THE FOLLOWING ARE THE principal books referred to
in the text.

Baldwin, T. W. *William Shakspere's Small Latine and Lesse Greek* (two
 volumes). Urbana, Ill.: University of Illinois Press, 1944.

Bate, Jonathan. *The Genius of Shakespeare*. London: Picador, 1997.

Bate, Jonathan and Jackson Russell (eds.). *Shakespeare: An Illustrated
 Stage History*. Oxford: Oxford University Press, 1996.

Baugh, Albert C. and Thomas Cable. *A History of the English Language*
 (fifth edition). Upper Saddle River, N.J.: Prentice Hall, 2002.

Blayney, Peter W. M. *The First Folio of Shakespeare*. Washington, D.C.:
 Folger Library Publications, 1991.

Chute, Marchette. *Shakespeare of London*. New York: E. P. Dutton and
 Company, 1949.

Cook, Judith. *Shakespeare's Players*. London: Harrap, 1983.

Crystal, David. *The Stories of English*. London: Allen Lane/Penguin,
 2004.

Durning-Lawrence, Sir Edwin. *Bacon Is Shakespeare*. London: Gay &
 Hancock, 1910.

Greenblatt, Stephen. *Will in the World: How Shakespeare Became
 Shakespeare*. New York: W. W. Norton and Co., 2004.

Gurr, Andrew. *Playgoing in Shakespeare's London*. Cambridge: Cambridge
 University Press, 1987.

Habicht, Werner, D. J. Palmer, and Roger Pringle. *Images of Shakespeare:*

Proceedings of the Third Congress of the International Shakespeare Association. Newark, Del.: University of Delaware Press, 1986.

Hanson, Neil. *The Confident Hope of a Miracle: The True History of the Spanish Armada.* London: Doubleday, 2003.

Inwood, Stephen. *A History of London.* London: Macmillan, 1998.

Jespersen, Otto. *Growth and Structure of the English Language* (ninth edition). Garden City, N.Y.: 1956.

Kermode, Frank. *Shakespeare's Language.* London: Penguin, 2000.

———. *The Age of Shakespeare.* New York: Modern Library, 2003.

Kökeritz, Helge. *Shakespeare's Pronunciation.* New Haven, Conn.: Yale University Press, 1953.

Muir, Kenneth. *Shakespeare's Sources: Comedies and Tragedies.* London: Methuen and Co., 1957.

Mulryne, J. R., and Margaret Shewring (eds.). *Shakepeare's Globe Rebuilt.* Cambridge: Cambridge University Press, 1997.

Picard, Liza. *Shakespeare's London: Everyday Life in Elizabethan London.* London: Orion Books, 2003.

Piper, David. *O Sweet Mr. Shakespeare I'll Have His Picture: The Changing Image of Shakespeare's Person, 1600–1800.* London: National Portrait Gallery, 1964.

Rosenbaum, Ron. *The Shakespeare Wars: Clashing Scholars, Public Fiascos, Palace Coups.* New York: Random House, 2006.

Rowse, A. L. *Shakespeare's Southampton: Patron of Virginia.* London: Macmillan, 1965.

Schoenbaum, S. *William Shakespeare: A Documentary Life.* Oxford: Oxford University Press, 1975.

———. *Shakespeare's Lives.* Oxford: Oxford University Press, 1993.

Shapiro, James. *1599: A Year in the Life of William Shakespeare.* London: Faber and Faber, 2005.

Spevack, Marvin. *The Harvard Concordance to Shakespeare.* Cambridge, Mass.: Belknap Press/Harvard University Press, 1973.

Spurgeon, Caroline F. E. *Shakespeare's Imagery and What It Tells Us.* Cambridge: Cambridge University Press, 1935.

Starkey, David. *Elizabeth: The Struggle for the Throne.* London: HarperCollins, 2001.

Thomas, David. *Shakespeare in the Public Records.* London: HMSO, 1985.

Thurley, Simon. *Hampton Court: A Social and Architectural History*. New Haven: Yale University Press, 2003.

Vendler, Helen. *The Art of Shakespeare's Sonnets*. Cambridge, Mass.: Belknap Press/Harvard University Press, 1999.

Wells, Stanley. *Shakespeare for All Time*. London: Macmillan, 2002.

———. *Shakespeare & Co: Christopher Marlowe, Thomas Dekker, Ben Jonson, Thomas Middleton, John Fletcher and the Other Players in His Story*. London: Penguin/Allen Lane, 2006.

Wells, Stanley, and Paul Edmondson. *Shakespeare's Sonnets*. Oxford: Oxford University Press, 2004.

Wells, Stanley, and Gary Taylor (eds.). *The Oxford Shakespeare: The Complete Works*. Oxford: Clarendon Press, 1994.

Wolfe, Heather (ed.). *"The Pen's Excellencie": Treasures from the Manuscript Collection of the Folger Shakespeare Library*. Washington, D.C.: Folger Library Publications, 2002.

Youings, Joyce. *Sixteenth-Century England*. London: Penguin, 1984.

BOOKS BY BILL BRYSON

SEEING FURTHER
The Story of Science, Discovery, and the Genius of the Royal Society

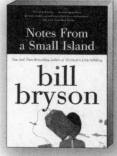

NOTES FROM A SMALL ISLAND

NEITHER HERE NOR THERE
Travels in Europe

THE MOTHER TONGUE
English and How It Got That Way

THE LOST CONTINENT
Travels in Small-Town America

MADE IN AMERICA
An Informal History of the English Language in the United States